Painting with Four Tubes of Paint

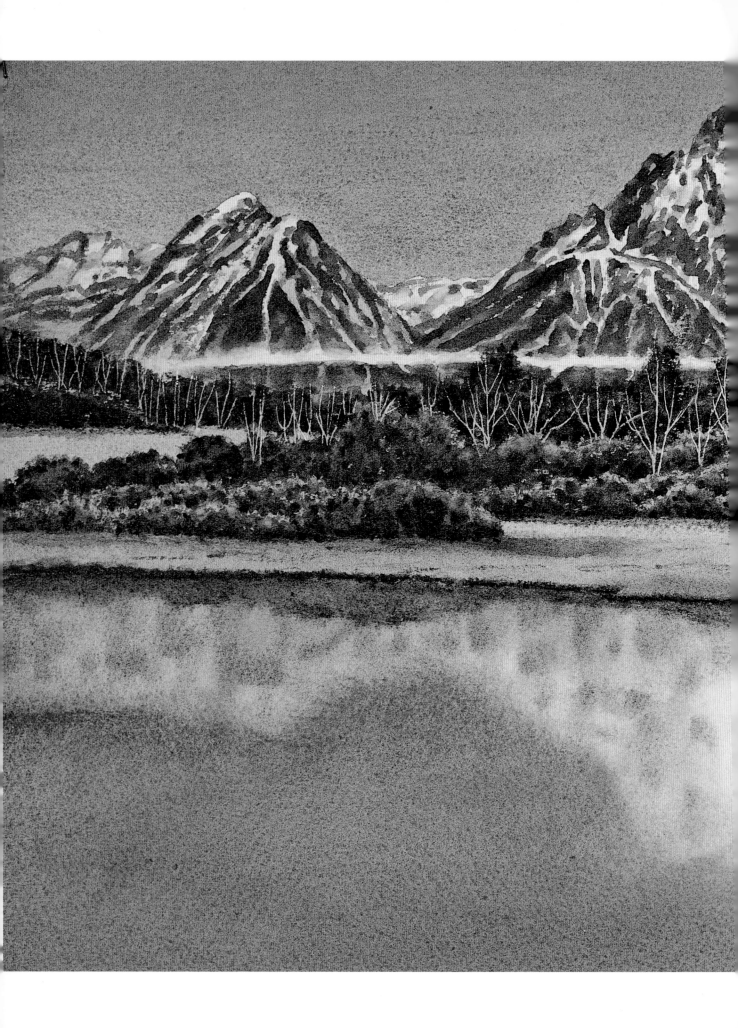

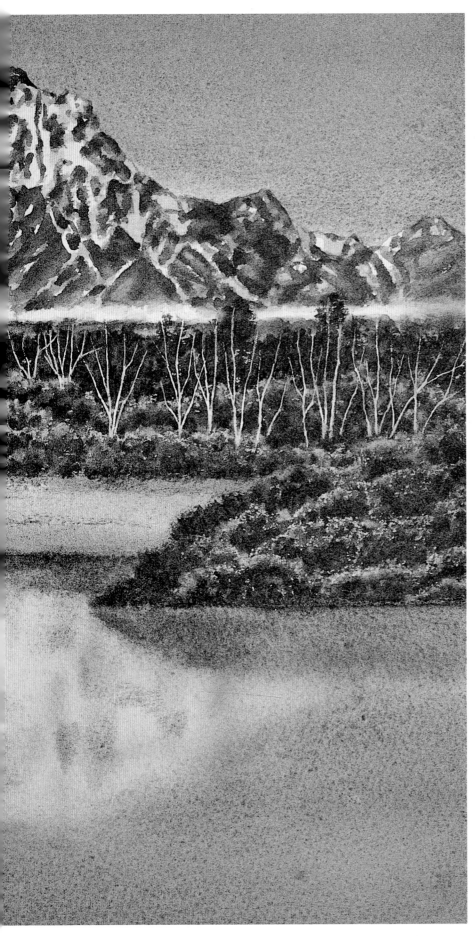

Painting with Four Tubes of Paint

A Simplified Palette for Watercolorists

Phillip Shaffer

WATSON-GUPTILL PUBLICATIONS/
NEW YORK

To Marian

Thanks

To Mary Suffudy for seeing the potential and guiding the direction.

To Candace Raney for doing the preliminary design and making it all work.

To Marian Appellof, who was always there when I needed her.

And to Grace McVeigh, whose patience and ability enabled her
to reduce a long, rambling manuscript to a concise, informative,
and, most importantly, fun book.

Thanks also to my three kids, Ron, Lori, and Bob, who had to
put up with years of being "painting orphans." A lot of those paintings
would never have gotten named without you.

Thanks to my parents and my wife's parents, who, once they
got over the shock of having an artist in the family, always
gave me the encouragement I needed.

And finally, thanks to my wife, Marian, who did much
of the original editing. Nothing is fun without her.

Pages 2–3:
COLD SUMMER MORNING,
watercolor, 11" × 14¾"
(27.9 × 37.4 cm).
Collection of David and Christine Henderson.

Edited by Grace McVeigh
Graphic Production by Ellen Greene

Copyright © 1990 by Phillip Shaffer
First published in 1990 by Watson-Guptill Publications,
a division of BPI Communications, Inc.,
1515 Broadway, New York, N.Y. 10036

Library of Congress Cataloging in Publication Data
Shaffer, Phillip.
 Painting with 4 tubes of paint : a simplified palette for watercolorists
/ Phillip Shaffer.
 p. cm.
 1. Watercolor painting—Technique. 2. Landscape painting—Technique.
I. Title. II. Title: Painting with four tubes of paint.
ND 2240.S53 1990 90-12324
751.42'2436—dc20 CIP
ISBN 0-8230-3889-0

Distributed in the United Kingdom by Phaidon Press Ltd.,
Musterlin House, Jordan Hill Road, Oxford OX 2 8DP
Distributed in Europe, the Far East, Southeast and Central Asia,
and South America by RotoVision S.A., 9 Route Suisse, 1295-Mies, Switzerland.

Manufactured in Singapore
1 2 3 4 5 6 7 8 9 10 / 94 93 92 91 90

CONTENTS

As an artist myself and a gallery owner, I've got the best of both worlds. With a watercolor brush in my hand and a fresh sheet of Arches on my drawing board, I'm as happy as I can be. And I can go on to my own gallery when my painting is done and talk to folks who are on vacation, enjoying themselves in the beautiful area where we live. Throw in an occasional hike in the mountains or a ski trip to a special frozen lake, and I keep wondering what I did to deserve this unique heaven.

I've blazed quite a trail through these United States since I was a boy first discovering art. Then, as I watched crayons melt on a radiator and realized the most beautiful patterns created by the colored wax trickling down the hot radiator and blending into yesterday's multicolored mixture, I knew I was an artist ahead of his time.

My experience with art grew more disciplined as I progressed through school, branching out even to cartoon making during high school. I studied under scholarship at the Art Institute of Chicago. But when my wife and I married, I enrolled in night classes at the American Academy of Art and worked full-time at Vogue Wright, the biggest art studio in the world at that time. Vogue Wright was an "art factory" that cranked out most of the artwork for the Sears and Ward catalogs and all the Spiegel catalogs. Their smaller accounts were dumped into General Accounts, the department I worked for. Because our department was not considered important, I was given assignments that long-established professionals would have killed for.

Two illustrations from an earlier stage in my career.

Producing art for my cousin, Bill, for silk screens forced me to preplan my colors and taught me how to tie areas together and how to separate them, since all the art was drawn on acetate and preseparated. That meant that all the blues had to be drawn carefully on one acetate, all the reds on another, and so on.

Doing feature wash drawings of everything from lawn mowers to bicycles and from metal buildings to rifles for a small studio specializing in newspaper illustration gave me the knowledge that enables me to paint landscapes today that look solid. I also learned that a corollary to solidity is texture. Everything has a texture, and, in watercolor, very often you have to paint texture at the same time as form. Doing two or three things at one time is what keeps watercolorists young!

When a friend and I formed a corporation, Product Illustration Inc., it was a multiple birth. Many of the concepts and procedures in this book were born at the same time, for I had to devise a system that I could use to quickly train the young artists we hired.

One thing led to another, and before we knew it, my wife and I had purchased the Four Seasons Gallery in Jackson, Wyoming, and were saying good-bye to Illinois. With a new place to live and paint, I even began to write about painting. A series of articles called "Painting the Four Seasons" was accepted for publication in the local Jackson newspaper and drew widespread attention. As a result of their success, I felt obligated to expand on my ideas, and so this book took shape.

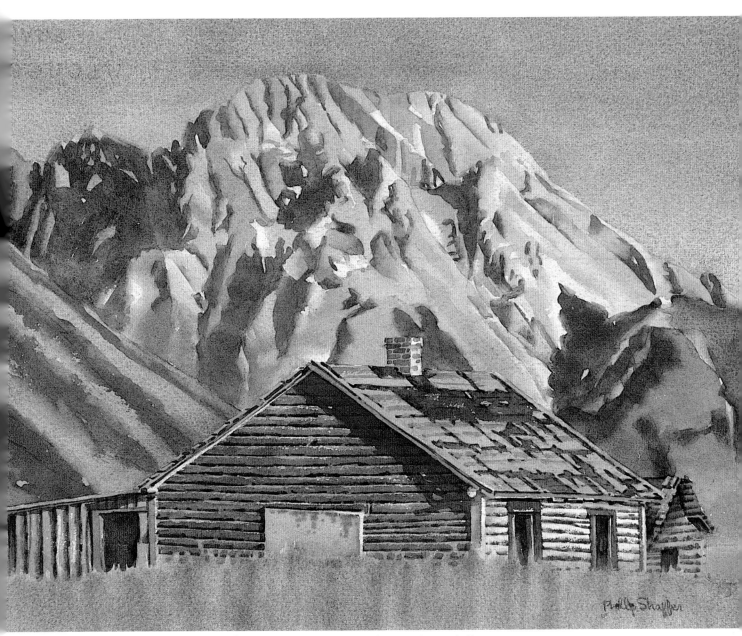

Mountain Cabin, watercolor, 10¾" × 14½" (27.3 × 36.8 cm). Collection of Robert and Mary Shaffer.

LET'S TALK ABOUT COLOR

First, let's cover some very simple color theory. There are only three primary colors: red, yellow, and blue. All other colors are made by mixing combinations of these three.

We all know that yellow and red make orange; red and blue make purple; blue and yellow make green. We also know that all three together make black, gray, or brown, depending upon proportions.

Pick a color—say, red. To darken it, add the opposite color—called the complementary color—to it. Green is the complement of red, and so green and red make black, gray, or brown—and, consequently, darken the red.

How do we know what the complement of the color is? You can use the "odd-man-out" theory. That is, if you mix any two of the three primary colors together, the one that's left—the odd man out—is the complement of the color you've created. If you mix red and yellow together to create orange, the primary color that's left is blue. So blue is the complement of orange.

As long as we're discussing color theory, let's consider what color a shadow should be. A phenomenon called simultaneous contrast can help us understand how this works.

If you stare at a bright red object for a while, then look at a gray wall, you'll see an image of that object in the same shape and size as the original but in the opposite color—green.

The same thing happens with color in paintings: the color of the shadow is always the complement of the color of the light. So if you are outdoors in a brilliant orange sunset, the shadows should be blue! But since reality is rarely that extreme, your shadow color will fall into the category of gray—warm gray or cool gray. And that brings up a corollary to the rule: If the light is warm, the shadows are cool, and vice versa. But remember that there are always a few warm reflected lights lingering around the cool shadows, and cool reflected lights hovering near the warm shadows. Why not include both? This enriches the colors in the shadows.

Try mixing a fairly dark color using lots of burnt sienna and a little cobalt. You'll get a dark warm gray. Now mix a darker color with the same two ingredients, but reverse the proportions. You'll get a darker cool gray. If you add the warmer color to a wet wash to darken its value, the shadows will be warm. If the shadows are too warm—or not dark enough—you can add the darker cool gray. This enables you to keep precise control of three things at one time: value

(light or dark), color (warm or cool), and intensity (gray or bright).

Colors are not quite the same when you're dealing with light as when you're dealing with pigments, but they're similar enough that, for our purposes, we'll consider the two interchangeable.

The color in each tube of paint is made with a different pigment or dye—and each pigment or dye has its own peculiarities. Take red, for example. If you dilute cadmium red, you end up with a chalky dull-looking pink. If you dilute alizarin crimson, your resulting color is a harsh, metallic pink. As a matter of fact, there's no red—when diluted—that will give you a perfect light red.

What do we do? We could decide which color mixtures are the ones we use most frequently in a landscape and figure out the least number of tubes of paint needed to achieve them. Or if we're really lucky, we might find a book like this one that tells us which tubes of paint to use.

Color doesn't have to be complicated. And the best color used logically can produce basic results. Whatever happened to the old yellow, red, and blue primary color approach we started our discussion with? Well, this is exactly what we will be using—in a simpler form.

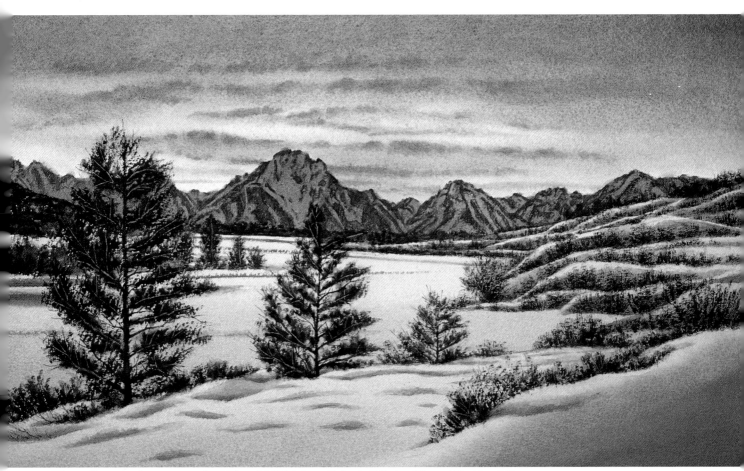

WINTER SUNSET AT OXBOW, watercolor, 8½″ × 14½″ (21.5 × 27.8 cm). Collection of Dr. and Mrs. Donald Dyer.

WHY CHOOSE A LIMITED PALETTE?

The purpose of this book is to provide the watercolor painter with a versatile palette that's adaptable to practically all landscape situations. Using four colors, you can complete ninety-five percent of your watercolors. One or more of the three auxiliary colors will simply allow you to create watercolor paintings number 96, 97, 98, 99, and 100.

You may think you can't paint a watercolor with only four tubes of paint! Or can you? Most of the watercolors in this book were painted just that way. Some were even painted with only two or three—and I defy anyone to tell which is which.

Painting with a few colors is called using a limited palette. That isn't unusual. What *is* unusual is that practically all landscapes can be painted using four tubes of paint—*the same four tubes of paint*—all the time. Eventually, three more colors will be introduced. But there will never be any reason for any others. Those original four colors will still be the only ones used in ninety-five percent of your paintings!

You may wonder if that will make all of your paintings look alike. Compare any two paintings in this book and notice how different each color scheme is. If the color schemes in your paintings start resembling one another, it will be because you choose to make them similar. I know artists who squeeze out a blob of everything Winsor and Newton sell before beginning a watercolor and—surprise! Same color scheme every time. The appearance of color variety in a painting is completely independent of the number of tubes of color the artist uses.

Using a limited palette will not limit the colors in your painting. Take another look at the paintings in this book. Is there any way anyone could possibly tell how many tubes of paint each one was made with? In any case, isn't the very act of painting a matter of making decisions that deliberately limit you?

The fact that you're reading this book suggests that you have probably already limited yourself to landscapes—and, yes, watercolor. When you decide to paint a particular scene, you're eliminating other scenes and limiting yourself to that one. When you prepare a sheet of watercolor paper, you're limiting the approximate size of your next painting and, probably, making a decision whether it will be a vertical or a horizontal format.

The advantages to painting with a limited palette are many. First of all, there is *cost*. As you already know, different colors cost different amounts of money. With one exception, the particular colors we'll be using are the less expensive colors. Also, because we're not using a little bit from a lot of different tubes but, rather, a lot of paint from a small number of tubes, you'll be able to buy in quantity. Where you live and where you buy your art materials will determine how much you can save, but by buying large tubes of watercolor (14 ml. or 15 cc., depending on the brand) and possibly buying more than one tube at a time, you are guaranteed to save money. Then later on, when you add

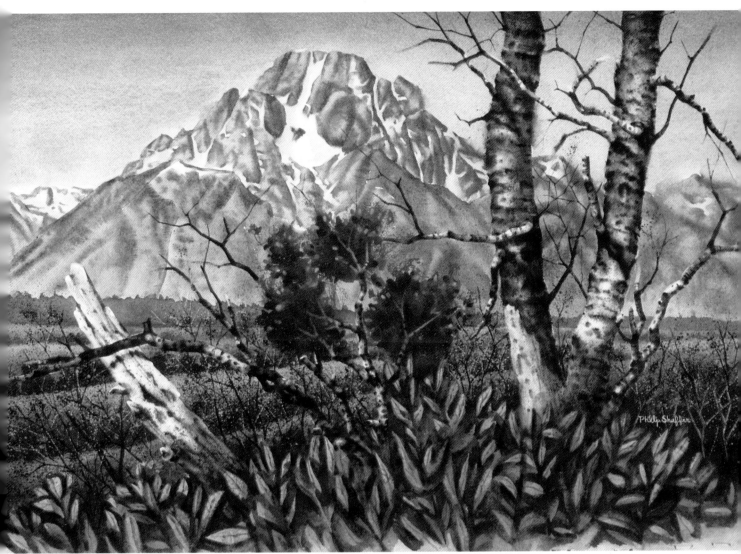

Mountain Mama, watercolor, 13½" × 20½" (34.2 × 52.0 cm). Collection of Dr. and Mrs. Samuel E. Dakil.

tubes number five, six, and seven to the menu, *those* can be the smaller-size tubes. You won't be using them often and you won't be using very much—and so you'll save again.

Another advantage to a limited palette is *control*. Many people get into trouble right off the bat because their color mixtures get out of control. The blues become too strident and begin shouting. Or the reds get too hot and pop out of place or, worse, begin muddying up the colors they're mixed with. By using the colors I'll be recommending, you will be telegraphing to your reds that they can go so far and no further! The same goes for your blues and your yellows. You can still get into trouble, but it's a lot harder.

Color coordination is another factor involved in your choice of a limited palette. By using a small number of colors, you'll be forced to use each one more often in one painting.

Consequently, you'll find yourself mixing a greater percentage of your palette into each of your mixtures. For example when you're using a four-color palette and you mix just two of the colors together, you're using fifty percent of your palette. Three colors would represent seventy-five percent. You will almost be guaranteeing perfect color coordination because you will have at least a little bit of each of your four colors in just about every mixture.

Familiarization is another advantage of using a limited palette. By now you have discovered that because of its chemistry, each color reacts differently when it's mixed with other colors. Obviously, the more colors you're working with, the more variables there will be—and the more you'll have to remember. Your goal is to become so familiar with your colors that, even without thinking, when you look at a mountain, you're able to say,

"Such-and-such color is the main color in this mixture with just a smidgeon of this and a dash of that."

Be aware that when you're using these colors, occasionally you will find that there are certain colors you simply won't be able to mix. Sure, you'll come close, but you may miss by just a hair. Resist the temptation to reach for another tube of paint. Remember that whatever you lost in absolute color fidelity to the original scene, you will gain back easily with a color cohesiveness you never thought possible.

Later, we'll introduce three additional colors that will enable you to mix just about every color possible. These three auxiliary colors will not make your paintings any better but will simply enable you to be more faithful to the original scene. *And the four basic colors will still constitute your palette for ninety-five percent of all your paintings!*

THE BASICS:
OUR FOUR TUBES OF PAINT

What four tubes of paint do we use to get our four basic colors—yellow, red, blue, and green? You may be surprised by the choices I've made, but when we discuss how these colors can be mixed together, you will understand why I chose them. Let's look at the colors in order: yellow (raw sienna), red (burnt sienna), blue (cobalt blue), and green (olive green).

Yellow The yellow we're going to be using is *raw sienna*. In watercolor, when you dilute raw sienna, you obtain a rich, warm, golden color. Diluted even further, it becomes almost a light lemon color—much cooler but without the harshness and opacity associated with the cadmiums. Also, without their cost!

When you use a more concentrated mixture, the color begins to resemble yellow ochre. But the extra blue and the opacity of yellow ochre can easily make the mixture muddy.

Raw sienna is especially versatile because it's a yellow that already has some of the red and some of the blue coloration we'd be adding anyway. It gives us a head start.

Red The red we'll be using is *burnt sienna*, which most artists usually think of as a brown—a reddish brown but definitely a brown. Like raw sienna, burnt sienna is out-and-out cheap. And when greatly diluted, it produces a warm soft pink with a hint of cool undertones. If less diluted, the color appears to be a brighter, hotter pink, but never really harsh. A concentrated mix becomes a very bright medium-value reddish brown.

Burnt sienna is especially valuable because it has a touch of yellow and a hint of blue, which we would be adding anyway. Again, with this color, we have a head start.

Blue Cobalt blue is ideal because of its versatility. It is the "truest" blue available and can easily be controlled to create grays or to "gray" other colors.

Compared to other blues, cobalt blue is the easiest to control. (Phthalo blue and sometimes ultramarine blue tend to be overpowering.) Cerulean blue is even weaker than cobalt blue. Anyway, cerulean and manganese blue are not really "true" blues.

But since cobalt blue is extremely weak, a little bit of any other pigment can alter the color. But we're going to consider this an asset because cobalt blue will not easily affect other colors when it is added to them. This is what the concept of controllability is all about.

The only really negative aspect is its cost. There are less expensive blues put out by some manufacturers to resemble cobalt, but because they usually have phthalo blue as an ingredient, they're difficult to control.

Green We've chosen *olive green* as the green closest to the final form in which we'll use it. Most of the other greens in tubes are dyes and are difficult to control and impossible to remove (either from the paper or from your favorite sweater). Also, they're unnatural-appearing and have to be drastically altered before they become usable.

Since olive green is a mixed color, each paint manufacturer has his own prescription for it, and so the color varies from company to company. I've tested most of them, and the one I find the cleanest is Winsor and Newton's, though all are easier to use than one of the harsher dye colors, such as phthalo green.

Pure Raw Sienna

Pure Burnt Sienna

Pure Olive Green

Pure Cobalt Blue

COMBINING TWO COLORS

Yellow + Red Adding raw sienna to burnt sienna starts tilting our mix toward a soft orange. Because we never achieve the harshness associated with the cadmiums, the change will be gradual enough so that we will be in control every step of the way.

Yellow + Blue Adding raw sienna to cobalt blue is a bit touchy. Although raw sienna is the yellow we'll be using as one of our four basic colors, combining raw sienna and cobalt blue will not produce much of a green. There's just too much red already in the raw sienna. Remember that the red plus the yellow in the raw sienna added to the cobalt means that you're combining all three primaries. Result? Black, gray, or brown.

You can use raw sienna to neutralize (gray) your cobalt, but you need to exert caution. Darkening or graying a color without a reasonable shift in color direction—warm gray or cool gray instead of simply a neutral gray—can lead to mud. However, raw sienna cautiously mixed with cobalt works perfectly to create beautiful silvery yellow-grays.

Red + Blue Burnt sienna mixed with cobalt blue is the mixture artists dream about. It's the ideal combination for most grays. Add more burnt sienna and it becomes a controllable warm gray. Add more cobalt blue and it's a comfortable cool gray. Push further and you can cleanly carry your warm gray into becoming pure burnt sienna. But you can't do the same thing with cobalt. Cobalt blue is so weak and expensive, it's easier (and cheaper) to start over.

Yellow + Green Because raw sienna is one of the ingredients in most olive greens, adding more raw sienna gradually increases that rich, beautiful golden glow. Miraculously, your mixture retains its "greenness" until it's almost all pure raw sienna.

Red + Green Burnt sienna, of course, increases the warmth of a green mixture, making it appear even more olive-colored and further still from the harshness of phthalo blue. Remember, however, that burnt sienna is our red—and red and green are complementary colors. Together they make . . . you've got it! On top of that, burnt sienna is the strongest of our four colors—so go easy.

Blue + Green Cobalt blue enables us to cool an olive green beautifully and controllably. With it, you're able to create just about every soft blue-green there is and, with a little help from the other two colors, a few that no one's invented yet.

Raw Sienna and Burnt Sienna

Raw Sienna and Olive

14

Raw Sienna and Cobalt

Burnt Sienna and Olive

Burnt Sienna and Cobalt

Olive and Cobalt

Raw Sienna, Burnt Sienna, and Olive

Raw Sienna, Burnt Sienna, and Cobalt

Olive, Cobalt, and Burnt Sienna

Olive, Cobalt, and Raw Sienna

16

COMBINING THREE COLORS

Mixing three of the four auxiliary colors together will give you a more subtle version of many of the mixtures we've already come up with. A raw sienna/burnt sienna/olive mixture can take you anywhere from a softer raw sienna color to a warmer greener one. But it can't get very cool; the only blue available is in the relatively warm cobalt.

Raw sienna, burnt sienna, and cobalt supply all three primary colors—but in a much more subtle version. But it *is* impossible to get much of a green out of this combination.

Mixing burnt sienna, olive, and cobalt is ideal for foliage. It can carry a mixture anywhere from a soft green to the browns.

Raw sienna, olive, and cobalt can give you soft cool greens, cool subtle yellows, and gentle blues. What it *can't* give you is the warmth of reds: There's no burnt sienna.

ALL FOUR COLORS TOGETHER

Working with all four colors gives one the effect of working with a complete art supply store full of tubes of paint, yet one is working with only four tubes. With these four colors in various combinations, one can create a variety of paintings depicting the beauty of the natural landscape.

By using the same four colors over and over again, I've become completely aware of what each of those colors can do. Believe me, when you've got a beautiful cloud-filled sky rapidly drying on your drawing board, that extra little bit of time that familiarity can give you might make the difference between a prizewinner and a lining for Tweetie's birdcage.

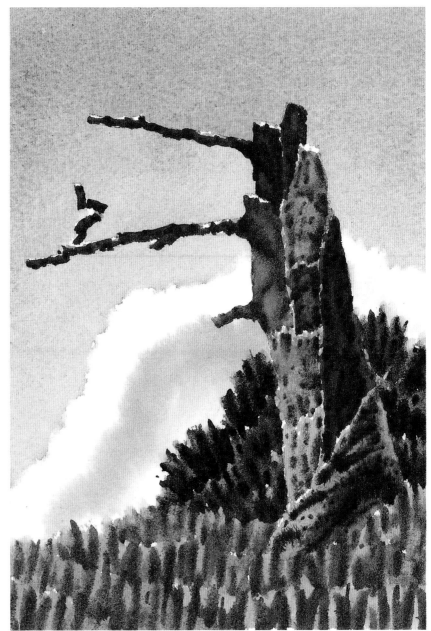

Raw Sienna, Burnt Sienna, Olive, and Cobalt

THE THREE AUXILIARY HUES

You won't be using any of these auxiliary hues very often. When you do, you won't use very much, so there's no point in buying large tubes. All three of these colors are quite strong, and they can easily overpower the gentle colors we've deliberately chosen so far. So use them gingerly.

Auxiliary Yellow What do we do on those rare occasions when we want a green that's brighter than olive green? Well, we could rush out to the local art supply store and buy five different greens. Or we could do it the easy way. Simply add a cool, intense yellow to the olive, which would brighten the green to whatever we want. My own favorite, *new gamboge*, is a very transparent, concentrated color. When you use it, you'll want to use it in very small doses; it *is* a dye. Once it's on that sheet of paper, not even dynamite will remove it!

Mixing new gamboge with our basic yellow—raw sienna—yields a bright, fairly cool, ochre color. Using it with our red—burnt sienna—will create a strange kind of burnt orange that has rather cool overtones. Finally, adding it to cobalt blue will create a variety of greens, most of them *not* too terribly clean.

Auxiliary Red One color that beginners want to splash all over a landscape is purple. Purple, of course, is a mixture of red and blue. Unfortunately, there's already so much yellow in our red—burnt sienna—that adding blue to the mixture simply combines all three primaries—and we end up with mud. Besides that, our blue—cobalt—already has yellow in it.

What we need is a red with no yellow in it at all. There are several excellent bluish reds on the market, but they're all dyes. Although *alizarin crimson* isn't perfect, it's the gentlest of this bunch of tigers, so we'll use that.

Cobalt blue, mixed with alizarin crimson, makes the most beautiful "soft" purples anyone would ever want. Adding burnt sienna continues to "tame" the tigers even more.

Raw sienna, mixed with alizarin crimson, creates a soft yet rich orange—warmer and brighter than possible using *burnt sienna* with raw sienna. Burnt sienna mixed with alizarin crimson creates a color hot enough to fry your enchiladas. Olive green, mixed with alizarin crimson creates some *very* dark darks—with a mysterious hint of green. New gamboge, mixed with alizarin, will give you anything from an intense golden color to a fairly bright orange to a bright red.

Auxiliary Blue Although it's not a dye, our last auxiliary color—*ultramarine blue*—may be the most likely to get us into trouble. Consider this. Every color has three attributes: its hue (is it red or blue?); its value (is it light or dark?); and its intensity (is it bright or grayed?). Ultramarine blue, straight out of the tube, is much darker in value than any of the other colors we've discussed. Having areas of extremely dark color can create what appear to be holes in a painting surface. Having cited all the *negative* aspects, we can now safely see what ultramarine *can* do for us.

Mixing alizarin crimson with ultramarine blue can yield purples that will put your eyes out—so be careful. Adding raw sienna to ultramarine makes dark-valued, not-too-intense, quite usable greens. Blending burnt sienna into ultramarine will give you grays, capable of shifting from warm to cool (as with cobalt) or the deepest blacks around. Mixing cobalt blue with ultramarine will allow you to deepen the value of cobalt and yet remain in the "pure" blue family. Also, it can shift ultramarine a bit toward yellow without sacrificing intensity. Finally, mixing new gamboge with ultramarine will create pretty bright greens, capable of retaining their intensity while becoming darker in value.

New Gamboge

Alizarin Crimson

Ultramarine Blue

New Gamboge/Raw Sienna

New Gamboge/Burnt Sienna

New Gamboge/Olive Green

New Gamboge/Cobalt Blue

Alizarin Crimson/Raw Sienna

Alizarin Crimson/Burnt Sienna

Alizarin Crimson/Olive Green

Alizarin Crimson/Cobalt Blue

Ultramarine Blue/Raw Sienna

Ultramarine Blue/Burnt Sienna

Ultramarine Blue/Olive Green

Ultramarine Blue/Cobalt Blue

CHOOSING YOUR MATERIALS:
PAINTS, BRUSHES, AND OTHER SUPPLIES

Most of the materials that I use have been accumulated through many years of painting. Much of it, *you* may find that you will never need. Lots of it you may already have. What you don't have can be found at your local art supply store and perhaps even at your local pharmacy or grocery store. None of it has to cost you that much—especially when your purchases are spread out over many masterpieces!

Pigments Since paint has become so expensive, I choose my brands according to my wallet. With two exceptions, my colors are made by Holbein in Japan. I buy them in large tubes (15 cc.) to save even more money. The agreeable texture of the Holbein paints—soft and smooth—enables me to mix my colors fast and easily. However, I use Winsor and Newton olive green because it is a cleaner green than the Holbein. I also use Winsor and Newton's cobalt blue, which is thicker and seems to have more cobalt pigment and less filler than the other brands. I buy the cobalt blue in large 14 ml. tubes.

I rarely use the three auxiliary colors—new gamboge, alizarin crimson, and ultramarine blue—and when I do, I won't use that much. So I purchase the small-size tubes—0.25 fluid ounces (7.5 ml), and I buy whatever reliable brand is on sale.

Brushes Almost the only brushes I use are Winsor and Newton's Sceptre brand, Series 101. They've got more spring than natural sable; they seem to give more control and last longer. They're a mixture of manmade filaments and natural Kolinsky (sable) and cost much less than pure sable. For the price of *one* medium-sized sable brush, you can own at least one of *every* size of Sceptre— and that's not such a bad idea. However, if you're on a tight budget, start with a #3, #4, #6, #8, and #12. You can fill in the missing numbers when you can afford them!

As part of their Sceptre line, Winsor and Newton also makes a Series 303 called liners or riggers. They're watercolor brushes with extra-long hair, which makes them perfect for fine branches, and so on. Get, at least, a #1.

I do have one all-sable Winsor and Newton, Series 7, #1 brush. Since I hardly ever use it, it will last a long time.

For those occasions when I need a pointed brush larger than the #14 available in the Sceptre line, I use a #36, Series 769, Robert Simmons White Sable Goliath. It, too, remains in good condition, since I rarely use it.

Grumbacher's #6142 Aquarelle flat is a wonderful series of brushes. I refer to it simply as Aquarelle throughout the text. The drybrush effect it creates by *pushing* it instead of pulling it is perfect for suggesting trees, shrubbery, and grass. The half-inch size would be best to start out with, and remember that it's important to use the paint relatively dry. The tip of the handle of the Aquarelle is beveled, for scraping light lines out of a darker, damp wash. It's a great tool.

I also use a one-inch flat brush, originally intended for sign painting. It's made of ox hair, and it's perfect for laying down large washes or wetting the paper. Delta makes it in the Dominican Republic; they call it their #170, 1-inch.

For wetting even larger areas, I use a 2-inch bristle brush. The one I have was originally made for rubber cement; there's no brand name on it. However, almost any 2-inch house-painting brush will do.

For scrubbing out, I use various bristle brushes, which I will discuss in the following chapters. One of my favorite "scrubber-outers" is a Delta brush, Series 920 and 970 (most of the writing is rubbed off). I don't know if it's

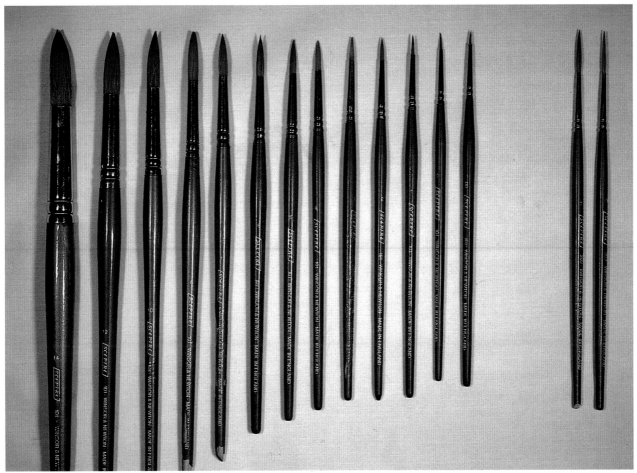

Left to right: Winsor & Newton's Sceptre brand, Series 101, #14, #12, #10, #8, #7, #6, #5, #4, #3, #2, #1, #0, and #00. The two brushes at the far right are Winsor & Newton's Sceptre brand, Series 303, liner (or rigger), #0 and #1.

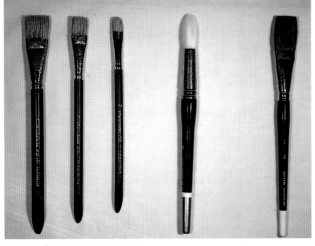

Left to right: Grumbacher Aquarelle brushes: 1 inch, ¾ inch, and ½ inch; Robert Simmons White Sable Goliath #36 brush and Delta #170, 1-inch flat brush.

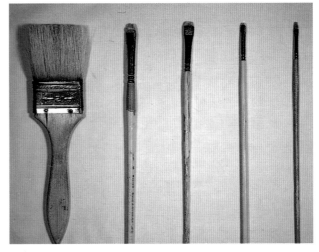

Left to right: Two-inch bristle brush, three oil painting brushes, one nylon-bristled acrylic painting brush.

still available. It has a gray handle and nylon bristles. The size I use measures a bit wider than an eighth of an inch. For spattering, I prefer to use old oil painting brushes rather than toothbrushes.

I would like to mention one thing I *don't* like in a brush. Although many of the Oriental brushes are beautiful, they have a nasty habit of going bald in the middle of a wash. One thing I don't need is a hairy wash!

Paper Since the paper surface is the most influential element in a watercolor, I recommend that a beginner try as many of the quality brands and surfaces as he can afford. Just make sure the paper is acid-free and all rag. The one I enjoy using the most is 140 lb. Arches with rough finish. The 300 lb. rough is even nicer, and it doesn't have to be stretched. But it costs more.

Now let's talk about stretching. Paper warps and buckles when it's wet. Since it's tough enough to paint a watercolor without facing the hills and valleys of an obstacle course, I "stretch" the paper. I soak 140 lb. Arches in lukewarm water in my bathtub for half an hour. Depending on their absorbency, other papers would require more or less time. This enlarges the paper. Then I staple the soaking wet paper to a half-inch-thick varnished plywood board that's a few inches larger than the paper. As the paper dries, it shrinks back to its original size, becoming as taut as a drum.

Masking Materials How do I paint a large, dark area that surrounds a small, complicated, lighter area before the whole mess begins to dry? I don't! I cover the lighter area with a liquid mask *before* I paint the darker area. I use Grumbacher's Miskit, not because it's better than the others (it isn't) but

because it's easier to see. The bright orange coloring that's added to the fluid allows me to easily locate where I put it and where I don't. However, make sure you follow the instructions on the bottle.

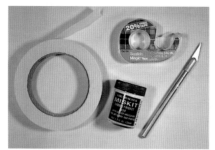

I also use masking tape and Scotch brand Magic Tape for masking. I especially like the Magic Tape because it's transparent and I can see exactly what I'm doing. Also, it's easy to use an X-Acto knife with a sharp #11 blade to cut the tape without cutting through to the paper. But be careful: Some of the softer papers can be damaged by the use of *any* of the masking materials.

Miscellaneous Materials
An inexpensive hair dryer is useful for speeding up the drying of washes. But don't turn it on until your wash has lost its shine. Otherwise, your watercolor may end up smack against the side of your neighbor's new mini-van!

One of the factors a watercolorist has to live with is the period of time it takes for a painting to dry. If you live in Florida, an air conditioner, a dehumidifier, or a hair dryer can help you finish your watercolor in the same year you started it!

But most of us have the opposite problem. In order to *slow down* the time it takes for a wash to dry, a few drops of glycerin work beautifully. But be careful. I have a friend who mixed too much glycerin into his wash—and if his watercolor dries by December 3, 2024, I win the office pool! By the way, keep in

mind that glycerin can cause a wash to smear or seep when it is used with a masking liquid.

Another device to slow down drying is a humidifier. I use an old, full-sized humidifier because Jackson, Wyoming, is one of the driest parts of the country. I suspect that an inexpensive desktop humidifier would be adequate in most places.

For quickly blending the edge of a wash, I use my brush on a cellulose sponge that I keep as wet as my wash so that I won't get any ugly "run-backs."

To get rid of excess paint, I touch my brush to a small piece of white blotter paper on my brush before it touches the watercolor paper. I also use blotters to lighten, remove, and texture a wash.

A small, plastic squeeze bottle is perfect for adding water to paint mixtures. I also use a large dish-washing detergent squeeze bottle (about 12 ounces) to dispense water in greater amounts—to wet the sponge, for example.

For years I used a glass half-gallon jar for water. Recently, I acquired a square, plastic water container especially for watercolor. It's divided by a partition into two separate containers, and it has notches along two edges to keep brushes from rolling. Although it is convenient and unbreakable, it doesn't hold enough water. I'll probably go back to the old glass jar at some point.

Niji makes a .5-mm mechanical pencil that I use with soft leads. It has a comfortable rubber grip. I love it.

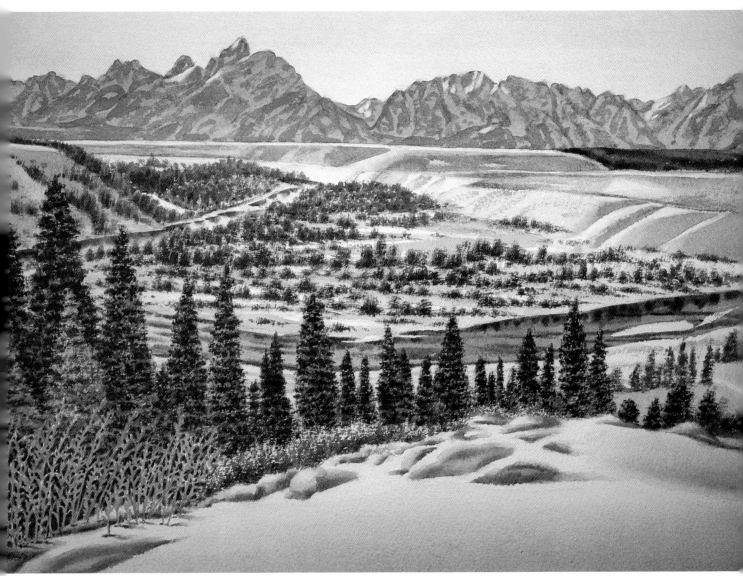

December at the Snake River Overlook, 10½" × 15" (26.6 × 38.1 cm). Collection of the State of Wyoming.

WATERCOLOR TECHNIQUES

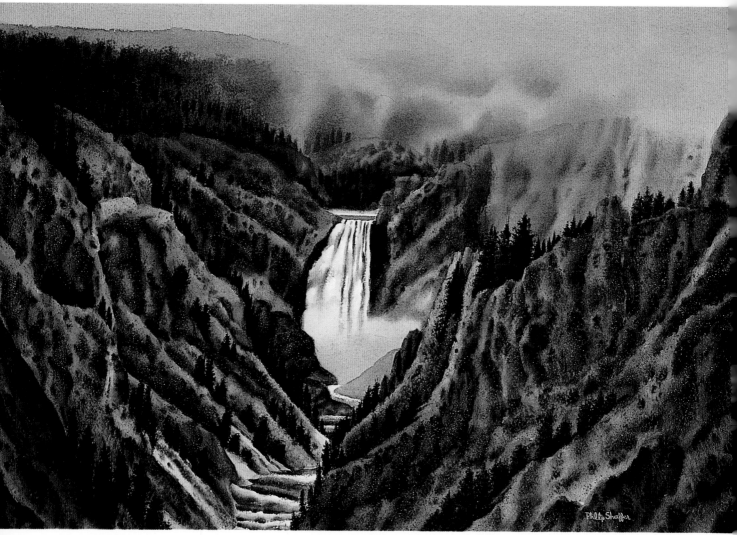

ONE OCTOBER MORNING, *watercolor, 14½" × 22" (36.8 × 55.8 cm). Collection of the artist.*

Flat wash

Flat wash with variation

Flat wash with three-dimensional variation

This chapter covers in a general way some of the basic watercolor techniques. Although you may already be familiar with them, you might want to read through in order to note any variations that I as an individual artist use. I'll be covering washes, drybrush technique, scraping, and masking.

Flat Washes Most how-to books show only one way to lay a flat wash. They tell you to tilt your drawing board and paint a very wet swath across the top of your paper. Then pick up more paint on your brush and, catching the bead of wet paint that formed below the first swath, paint a second swath, and so on. At the bottom, dry your brush on a blotter and absorb the puddle. That's basic and it works.

However, there may be occasions when you want some variation in your flat wash. Well, there's another way! First, "double-wet" your paper. Wet it once with clean water and a large brush, and then while it's still damp, rewet it. The first wetting simply makes the paper receptive to the second wetting, and the second wetting gets through to the fibers.

Now, add your watercolor wash. The color will spread in all directions on the wet paper, and you don't even have to tilt your board. You'll end up with a flat wash that's probably a little lighter than the wash in the previous demonstration because of the water already in the paper.

Using the same method you just used, you can also add some soft texture. Simply add some darks and permit them to spread. To create a more three-dimensional look to your texture, make one side of your shadow tone crisper than the other.

Graded Wash Now that you see how easy it is to create and alter a flat wash, let's paint a graded wash. Once again, double-wet your paper, but this time tilt your drawing board. Begin the top swath with your brush loaded with color. Then, for the second swath, dip your brush into clear water *without* rinsing it out. You'll be carrying a more diluted load of paint with each stroke, and the tone will become lighter and lighter.

Would you like to be able to alter the speed of the transition? By rinsing the brush a bit between paint "pick-ups," you can lighten your graded wash at a faster clip. By adding a light wash rather than pure water, you can slow down the transition. Beginning to see how easy it is to control?

Of course, it's also possible to make a wash darker. Simply wet your paper and begin your wash at the top. Then, instead of adding water or a lighter wash, add a *darker* wash. It's a little trickier because the darker, second wash wants to dry faster than the first wash. However, if your paper was dampened completely (but not wet), you shouldn't have problems.

Since you were having such a good time with your graded wash, you never noticed that that second approach was actually the old terror *wet-in-wet*. That example was done with different values (lighter and darker tones) of the same color. Now let's try the same thing with *different* colors. To enrich the apparent color in a painting, always try to change the *color* whenever you change the value.

Another way to paint a graded wash is to first paint a single color over an entire area and let it dry. Then add a second tone (darker and of a different *color*) over it with a graded wash. As the second color is gradually diluted, more and more of the first color shows through. If the first color is *raw sienna* and the second color is cobalt, don't look now—but you just painted a perfect sky!

It may not be possible to see, because of the limits of color printing, but the glow in the previous color swatch was created by tiny chunks of cobalt blue settling in the crevices of the watercolor paper *next* to the pieces from the original raw sienna wash. Only transparent watercolor automatically creates the kind of vibration between colors that the French impressionists worked so hard to achieve.

Graded wash, dark to light

Graded wash, dark to light (faster transition)

Graded wash, dark to light (slower transition)

Graded wash, cool light to cool dark

Graded wash, cool dark to warm light

Drybrush Now, let's move on to drybrush. Drybrush is created when the brush skips over the valleys on a piece of watercolor paper and deposits paint only on the ridges. By using relatively dry paint and by painting with the *side* of the brush—rather than the point—you can facilitate the effect.

But that's not the only way to create this effect. If you dip your Aquarelle brush into paint, dry it on a blotter, and *push* the brush instead of drawing it *toward* you, you'll automatically create the most beautiful foliage strokes imaginable. A few darks complete the effect.

Scraping Since we've got our Aquarelle brush out, let's investigate how perfect the tip of the handle is for scraping. First, using the business end of the brush, let's paint some drybrush foliage. Then, while the foliage is damp but no longer wet, use the *sharp* edge of the flat plastic tip to scrape out some branches. By scraping beyond the perimeter of your foliage color, you'll create the illusion that the branches continue.

Drybrush

Drybrush used with wet-in-wet

Drybrush scraped with tip of Aquarelle

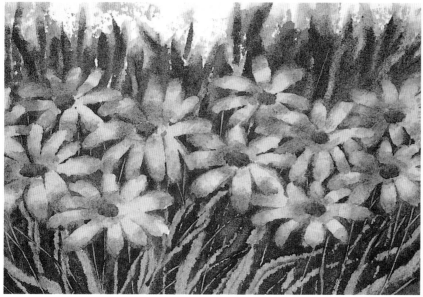

Masking

Masking We bought a liquid mask because it's so valuable for blocking out small or complicated edges that we want to keep white while painting a darker background. Because all liquid masks are so hard on brushes, the #3 Sceptre brush you bought will be reserved only for that purpose. To use it, first dip the brush into soapy water, then into the liquid. You'll probably want to soften the harsh, abrupt edge you get when you remove the liquid mask from your painting. Gently scrubbing with one of our "sawed-off" bristle brushes works perfectly for that. Aside from using a liquid mask for the petals of the flowers, see if you can spot how many different techniques I used in this illustration.

You can also get some stunning *textural* effects by using a liquid mask with drybrush, spatter, crosshatch, and forty-seven other things that I'd never be able to dream up. But *you* will—and that's what keeps watercolor so exciting!

Flat Strokes For broader areas, such as rocks or mountains, try using more—or all—of the flat edge of the Aquarelle. You can get effects that you can't get any other way!

Scraping with flat edge of Aquarelle

DEMONSTRATIONS

In art school I was taught to lay out a watercolor by blocking in each of the elements with a local color, then adding shadow and detail. I quickly discovered that the second coat dissolved the first coat and, *voilà*, mud! However, I found I could avoid the problem by painting in sections wet-in-wet. The biggest problem then is when I reach the last element, how do I know the pieces will fit?

I carefully plan this with small black-and-white sketches, full-size black-and-white sketches, and/or color sketches. For example, in my painting *The 7:30 Out of Atlanta* (page 63), I made no sketch or pencil drawing at all. But on *Where Have All the Flowers Gone?* (page 69), I would get lost without a "road map."

Planning ahead extends to my color mixtures also, but I've got a lot of help in that department. By using my four special colors, I'm able to create mixtures in less time, with less effort, and a lot more confidently than before.

To make *your* job more effortless, in all the color mixtures mentioned in this book, the color listed first is the color used in greatest quantity. The color listed second is second in quantity, etc. Now for some fun!

WINTER OVERLOOK,
watercolor, 14½" × 11" (36.8 × 27.9 cm).
Collection of Dr. and Mrs. Richard Hobsfield.

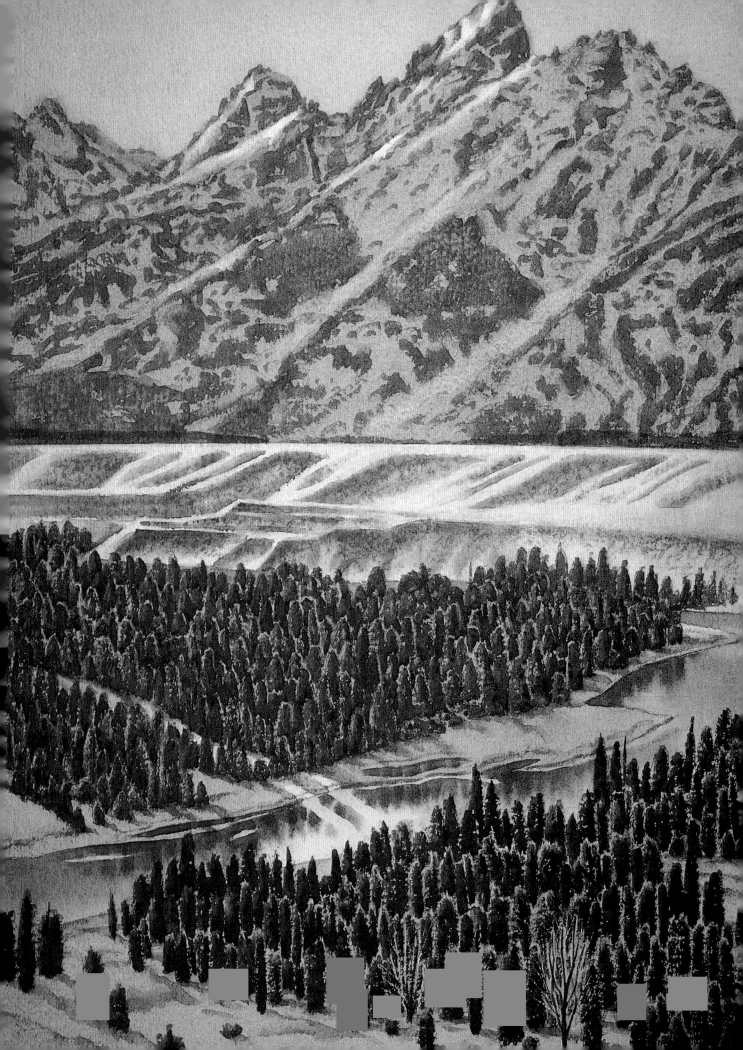

Working Wet-in-Wet

1

Autumn in central Indiana has a special magic. Leaves begin to change colors; the water level in rivers and streams is lower after the hot summer, and the air is crisp but not yet cold. Turkey Run State Park in Parke County has all these attractions, plus one more—covered bridges. Those charming relics in a startling reddish brown seem to have been positioned there by early architects with the watercolor painter in mind.

For this painting, I used a light wash of raw sienna in the sky and shrubbery area (except for the foreground shrubs at the extreme right). A few drops of glycerin added to the wash bought me some time for second thoughts. I mixed two tones of pure cobalt blue for the sky—light and lighter still. Pure cobalt could be used because the raw sienna underpainting toned it down. For the shrubbery I used a medium-value pure olive.

My first dark was a rather warm mixture of burnt sienna and cobalt. My darker dark was a blue—dark mixture of cobalt and burnt sienna. In the case of my darks, I mixed my lighter shadow color either warm or cool, and my darker shadow just the opposite so that I could control not only the value of my shadows but also the color and temperature.

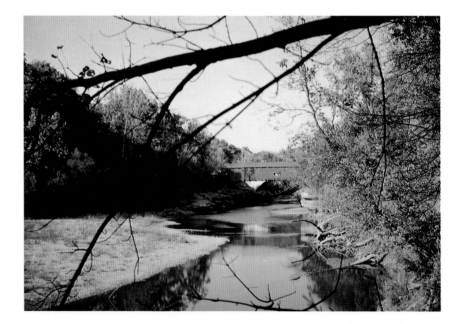

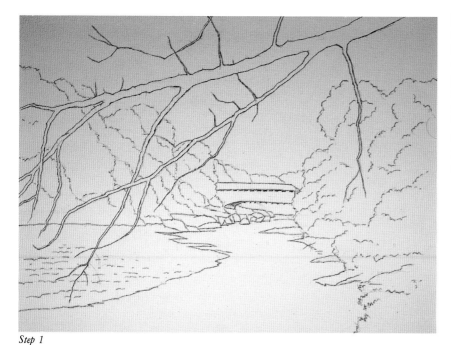

Step 1

Step 1. To begin, I penciled in the riverbanks, the tree line, and the covered bridge on my 140 lb. rough Arches watercolor paper. Then, on a separate piece of tissue, I designed the foreground tree so that it could be shifted around until I decided on the right place for it. When I had, I traced the tree onto my drawing. Masking out the bridge with a piece of tape, I used my X-Acto knife and a #11 blade to cut it to shape.

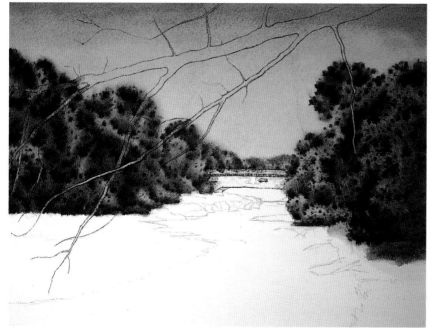

Step 2

Step 2. With clear water, I saturated the sky and shrubbery area, then removed the standing water with a squeezed-out brush. With my premixed light raw sienna base color, I put a wash over the entire wet area, then, with the paper still very wet, I added my first sky color—the darker, pure cobalt blue wash—to the top of the painting, gradually blending it into the lighter cobalt wash. I painted my shrubbery area into position with my premixed olive wash. While it was still quite wet, I dropped in my lighter dark—burnt sienna and cobalt. When the paint was less wet, I added my darker, bluish colored dark (cobalt and burnt sienna). I tried to show contrasting tones in the shrubbery in the foreground and in the background. Also, I had to remember to spot darks around the masked areas where the lighter-toned bridge would eventually be. With the tip of the handle of my Aquarelle brush, I scraped out the larger foreground tree branches from the damp wash. Then, with a barely wet brush, I softened some edges where the foreground meets the shrubbery.

Step 3. I premixed a light base (local) color of raw sienna and cobalt, adding just a touch of burnt sienna for the foreground gravel areas. Diluting the same two shadow colors I already used for the foliage gave me the correct colors for the shadows of the gravel, since, as we've already said, the color of the light determines the color of the shadows. If the color of the light source remains the same throughout, then the color of the shadows remains the same also. I painted in the base color with short, choppy, horizontal drybrush strokes to suggest the texture of the gravel and mud, working section by section, adding my first dark and then my second as I went along. With the tip of the handle of the Aquarelle brush, I scraped out occasional highlights. I then finished off the foreground shrubbery with the previous shrubbery colors and waited for everything to dry before removing the tape.

Step 4. I painted a diluted pure burnt sienna over the entire bridge area (sans roof), and while it was still damp, I added my two darks for the cast shadow and the hint of the underside. I wanted the roof to be a cool gray to reflect the sky, so I painted it in a diluted version of my darker dark. After softening a couple of edges, I added a few more darks to the rocks.

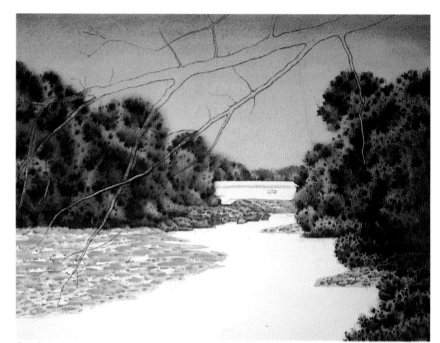

Step 3

Step 4

PARKE COUNTY AUTUMN, watercolor, 11¼" × 15" (28.6 × 38.1 cm). Collection of Mr. and Mrs. David Rickett.

Finished Painting. In

painting the water area, I began by wetting the entire area, and before it could dry, I wet it a second time. This "double-wetting" guaranteed me the maximum time to do my wet-in-wet wash. Because the color of water is a toned-down version of whatever it reflects, I added a bit of cobalt to the raw sienna base I used for the sky. (Remember that base color still has glycerin in it, so I don't add more.) The lighter, pure cobalt sky color was introduced at the top and blended into the darker cobalt sky color as I came down.

Locating the reflections of the trees with the pure olive foliage color, I also

introduced the pure burnt sienna reflection of the bridge. Next I added my warm and cool shadow colors to the reflections of the foliage. Where necessary, I darkened areas that seemed to be drying too light.

To paint the foreground tree branches, when everything was dry I mixed a cool gray-brown base color (burnt sienna and cobalt). Painting section by section, I brushed in the base color with a quick, slightly dry brushstroke. Then, while it was still wet, I added my two darks. The indication of the vertical boards in the bridge were added by putting a drop of my diluted warm dark (burnt sienna and cobalt) into an old ruling pen and, using

a straightedge, stroking it in. I made sure I checked that the contrast decreased at an even pace (both in the real and reflected image) as I went back in space. Also, I made sure the bridge—the center-of-interest—"popped" properly.

In finishing up, I found the contrast in the foreground rocks and mud too distracting. I carefully added another wash of the very same color (raw sienna, cobalt, and burnt sienna) over the entire area, killing most of the whites. In a few places where I thought the painting seemed too bland, I came back again with my cobalt/burnt sienna mix and, by George, I think I've got it!

Creating
a Sense
of Depth

As a group, the Hawaiian Islands are possibly the prettiest part of this beautiful, diverse country of ours. Diamond Head, on the main island of Oahu, has become the symbol for the entire chain, but to my watercolorist's eye, the surrounding area seemed far too developed for my painting. With a flick of my magic brush, I removed the crowds, the glitz, the undesirable development of the last one hundred years.

I felt an overwhelming obligation to use every device available to make my painting look three-dimensional. Even though we may not always be aware of it, when we focus our eyes on an object, we can see only our main point of focus sharply. Everything else is seen less sharply—with our peripheral vision, the "corners" of our eyes. This is what made the old Cinerama (and, to a lesser extent, today's Cinemascope) look as three-dimensional as it does. When painting realistically, we can create that effect by making part of the painting blurred, unsharp, fuzzy, or whatever you want to call it. In watercolor, I call it wet-in-wet.

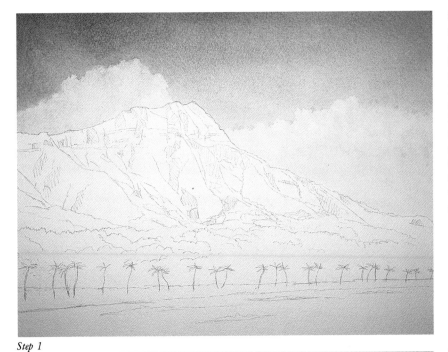

Step 1

Step 1. I used a pencil to begin reorganizing the foreground into a simpler setting, reducing the emphasis on the middle-ground foliage. When I was satisfied with this simpler grouping, I used masking tape to protect the three edges of the paper that touched the sky. First, I premixed an aqua sky, using cobalt and olive. To make the presoak easier, I turned the board upside-down until the paper was evenly wet, then I turned it back again. To create a graded wash, I began at the top, dipping less and less into the paint as I went down.

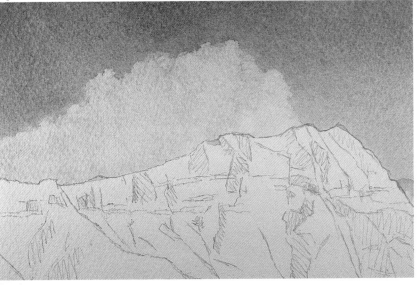

Step 2

Step 2. When my sky wash had lost most of its shine and was a little wetter than damp, I blotted out the clouds, using a crumpled piece of tissue. If the paint flooded back in, it meant the paper was too wet, and I simply tried again.

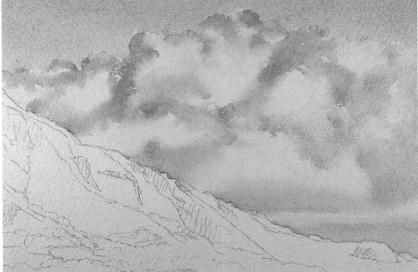

Step 3

Step 3. To model the clouds at right, I used three dilutions of cobalt and burnt sienna. The darkest was quite light, and the lightest was almost pure water. I painted the clouds section by section, softening some parts by wetting first and letting other parts remain sharp. I created a third kind of edge— drybrush—by moving the brush quickly in other places.

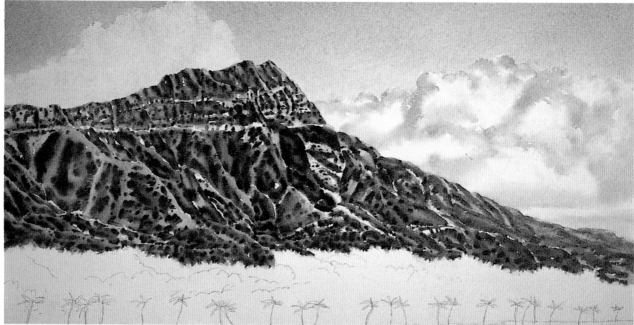

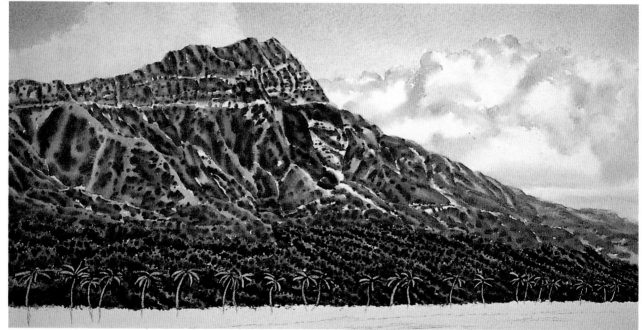

Step 4. The base color for my mountain was an odd yellowish color, combining raw sienna with burnt sienna and cobalt. My first dark was burnt sienna and cobalt, and my darker dark was cobalt and burnt sienna. To avoid the monotony of too many trees, I carefully designed a cut-off point—an edge—where the rock of the mountain ended and the trees began. To prevent the transition from being too abrupt, I used similar values to tie the two edges together.

Step 5. My base color for the middle-ground shrubbery was pure olive; my first dark was a warm burnt sienna and cobalt; and my darker dark was a bluish cobalt and burnt sienna. I used a fairly dry half-inch Aquarelle brush to paint my base color with a jabbing, pushing kind of stroke. Then, I worked with a #6 pointed brush for my first dark. A #5 brush, with my darkest dark, came last. To handle all these loaded brushes, I hold them in my left hand (I'm right-handed) in the order in which I plan to use them. I hold a wet brush in my "third hand"—my mouth—ready for instant blending or wiping out. Ignoring the palm trees, I began painting the shrubbery in rows, beginning in the back and making sure the rows are irregular and vague.

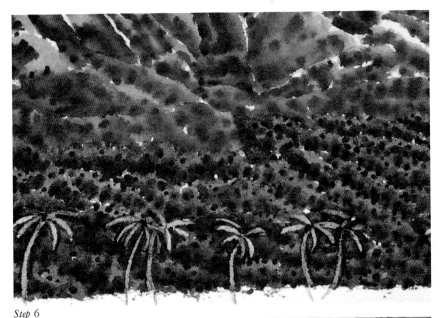

Step 6

Step 6. I painted the entire background the same way, and then used the handle of my Aquarelle to scrape out the curving strokes of the palm trees. Here, timing's the whole thing. If you scrape too soon (when the wash is *wet*, instead of just damp), the paint will come flooding back into the area you just scraped. If you wait until the paper becomes too dry, nothing will happen. Be careful not to get too enthusiastic scraping. You might bruise the paper, actually making the area darker. (By the way, scraping doesn't work as well with soft papers, such as Whatman or Aquarius, which absorb the paint too readily.) Colors can also affect the result. Dye-based colors, such as my auxiliary colors—alizarin crimson and new gamboge—actually *dye* the paper fibers and can't be scraped.

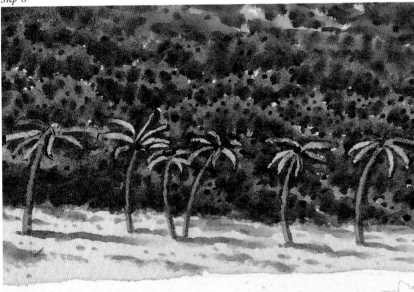

Step 7

Step 7. I underpainted the sand with a diluted version of the same base color I used for the mountain—raw sienna, burnt sienna, and cobalt. When that was completely dry, I painted in the palm tree trunks, right over the light stain that remains after scraping. I used raw sienna with a little burnt sienna, as bright as I could mix it and still keep it in the midvalue range. Using burnt sienna and cobalt, I added the cast shadows and the little mounds on the sand. While everything was still damp, I added a midvalue of my standard cobalt and burnt sienna to cool and deepen the shadows.

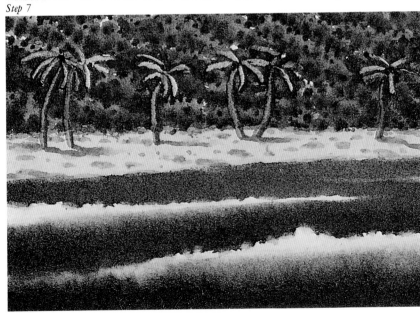

Step 8

Step 8. For the ocean, I mixed a very rich value and a more diluted value of turquoise, using cobalt and olive. Then I soaked the water area, carefully avoiding places where I wanted the foam to remain white. I applied the lighter value first and switched to value number two. Remember, since both cobalt and olive are weak colors, they really have to be piled on! Softening many of the leading edges of the waves with an antique bristle brush, I also softened pieces of the trailing edges—thereby suggesting mist from the breaking waves.

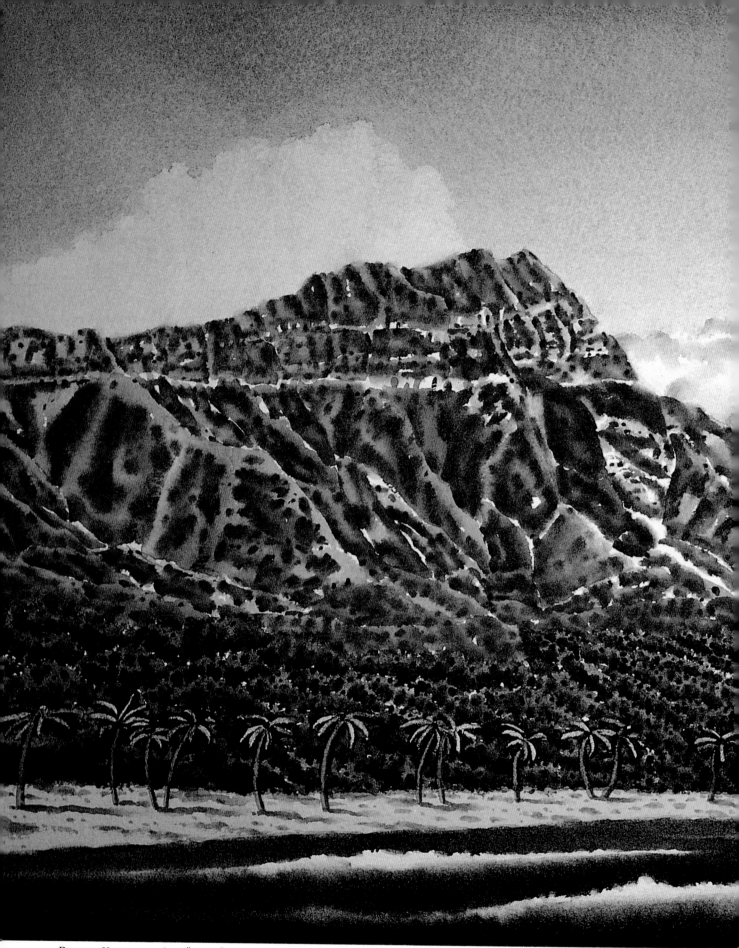

DIAMOND HEAD, *watercolor, 11″ × 15″ (27.9 × 38.1 cm).*

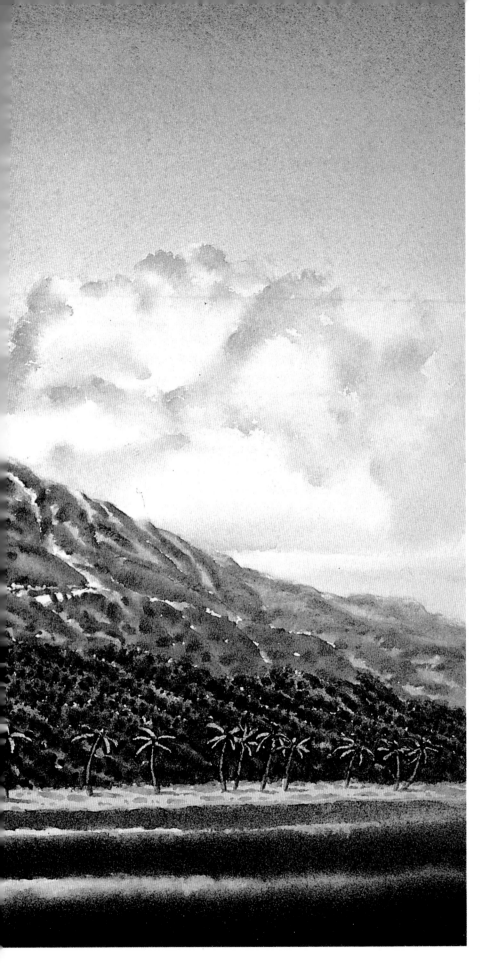

Finished Painting. I darkened some of the puffy edges of the clouds and lightened a few others. And I can almost hear the ukuleles now!

Capturing Rugged Textures

3

The word *park* in Colorado has its own unique meaning. It refers to a lower, open piece of land surrounded by nearby peaks. One visit to Rocky Mountain National Park and you understand the need for special definition. It is so big, so high, and has so many separate, beautiful "parks" that definitions we've used for other places just don't work. My oldest son, Ronald, who lived in Loveland, Colorado, a few years ago, had the world's greatest job—he was actually *paid* to go into Rocky Mountain National Park every day and take photos. That gave us an excuse to do the same when we visited him. Also, it provided me as a painter with scenes I could use to create various textured effects.

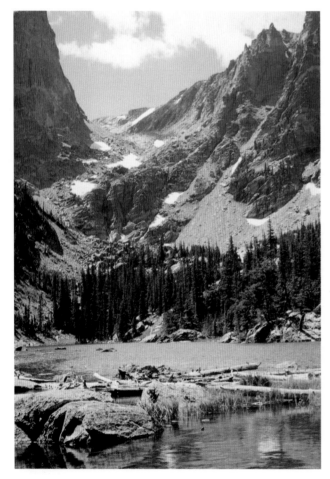

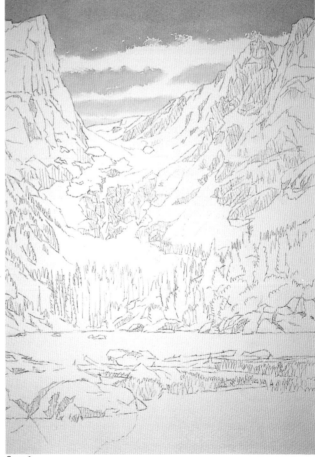

Step 1

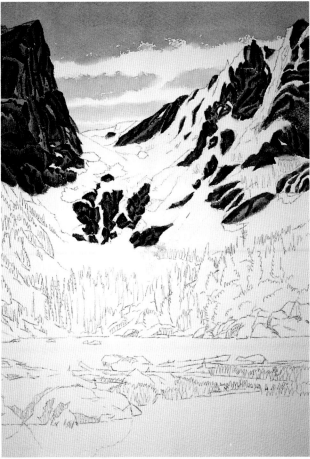

Step 2

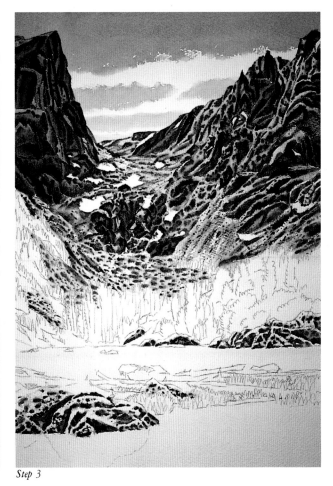

Step 3

Step 1. Since one can find so much to paint in the mountains, I always limit myself by working from a comprehensive pencil drawing, which I use as a general guide. The shaded areas serve as a code to indicate what each surface is. When I began the painting, I used a clean mixing tray and clean brushes for my first light, pure cobalt wash. Then I mixed a second version, using more water, and then a third with still more water. On dry paper, I painted in the top of the sky, using the darkest wash and plenty of drybrush. While that was still wet, I blended some edges. Leaving a white band for clouds, I painted the second blue strip with the next lighter blue. Another white band of clouds, and then I socked in the third, lightest strip of blue. You want to create a variety of edges (drybrush, blended, and crisp) to create interest in a simple sky. Remember, also, to watch linear perspective—the closest strip of clouds (and sky, too) should be the widest, and the farthest strip the narrowest.

Step 2. The logical way to begin to paint so many rocks is to start with all the major shadow areas. That should work because getting the tones of the shadows down will help you determine the tones of the *light* areas. Here, my base color was a middle-value cobalt with a little burnt sienna. My first dark was my standard burnt sienna and cobalt, and my darker dark was cobalt and burnt sienna. I had to make sure the major contrast was between the entire shadow area and the entire lighted area. If there was too much contrast within the shadow area, when I got to my lights, it would break up the form. Since the main purpose of a painting is to capture the feel and smell of a place, I wasn't necessarily interested in painting every pebble. But that's not a license to be sloppy. Some accuracy is important or one can easily lose the sense of place.

Step 3. Since the lighting here was the same as in the last step, my two darks remained the same—burnt sienna and cobalt for number one, and cobalt and burnt sienna for number two. My base color was a very light, warm value of cobalt and burnt sienna.

Step 4. I used a "semi-drybrush" in the lighter area to suggest the rubble of the rocks. This combination texture was accomplished by painting the lighter, base color with a fairly dry brush, then going very quickly into the still-damp base with my two darks.

Step 4

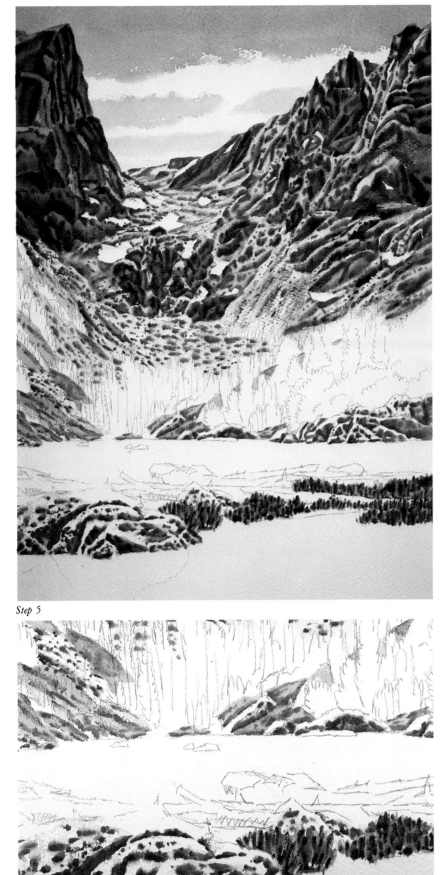

Step 5. For the background grass I mixed a cool base color of olive with a little cobalt. Because it's difficult to make a small area like this show up in a busy painting, I simplified it by using only one dark—cobalt and burnt sienna, diluted.

Step 5

Step 6. I painted the foreground grass with a rich, pure olive green to make it come forward. I used both darks to model and create the grass texture.

Step 6

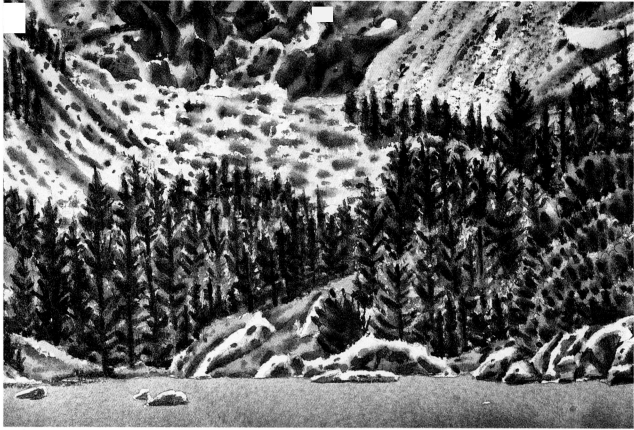

Step 7

Step 7. I used a mishmash technique on the trees—a little direct painting, a bit of wet-in-wet, a smattering of drybrush, some blending, and even a touch of finger blotting. Finger blotting means that you press your finger into a damp wash to lighten a color. It creates a unique texture that can suggest faraway grass, wood, or rocks. It's important to learn a variety of ways to create the appearance of nature. My advice is to study how different artists paint trees, rocks, and grass, and use that information to develop your own ways to paint them.

Finished Painting. First, I masked out the logs and the debris below the middle-ground chunk of water. Painting around the foreground weeds, I carefully wet the entire foreground water area with clean water. Then I painted my lightest sky color into it. Using the colors I used on the real thing, I began painting the *reflections* of those things. I made sure the reflections were below the objects they reflected, and I provided all kinds of wet-in-wet wave indications.

Remember, in painting white snow—not too dark. To avoid a pasted-on look, I used drybrush and softened the edges with a damp bristle brush. To blend, I allowed some of the whites of one object to leak into the whites of the neighboring object. I finished up by toning down lights or darks that "popped" too much and edges that were too harsh.

DREAM LAKE DREAMS, watercolor, 15½″ × 10″ (39.3 × 25.4 cm).

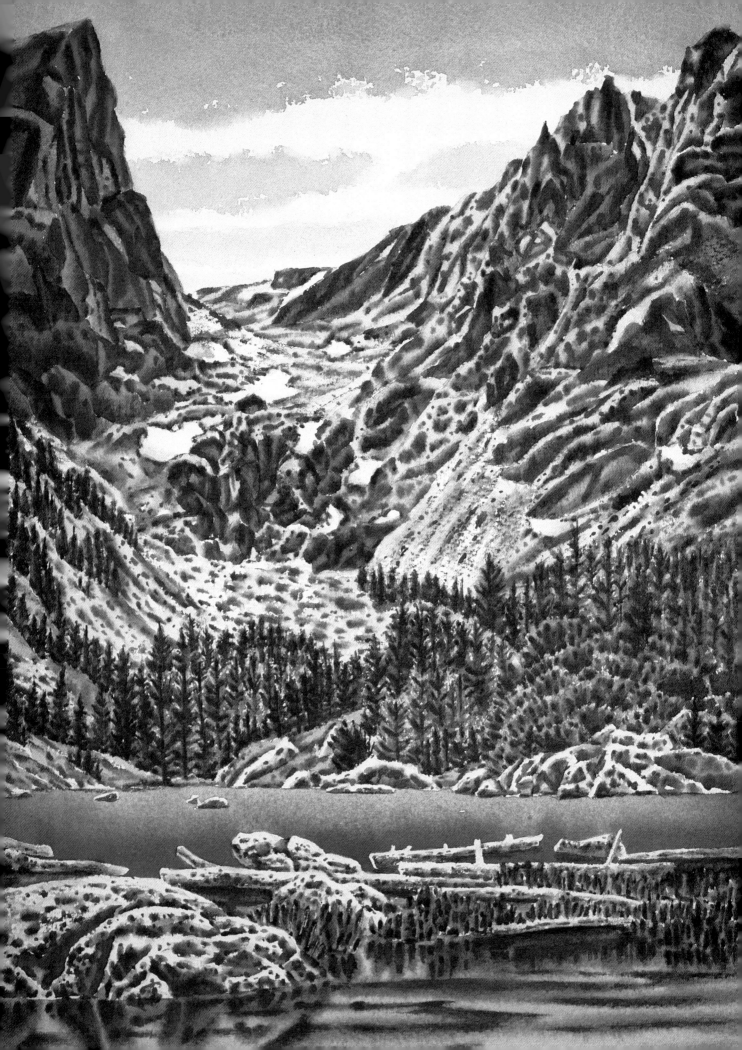

Using Masking for Special Effects

4

There is absolutely no subtlety in Zion National Park. The sky is the brightest, deepest blue, and the rocks are the reddest and the brightest orange. And, of course, there are flowers everywhere. How is it possible for mere mortals to capture the dramatic beauty of Zion? Unless my watercolor paper is a city block long, it's not possible. The closest I can come is to paint one small representative corner of the park and allow that to become a symbol for the whole. Remember, I'm not painting Zion National Park; I'm painting a *picture* of Zion. The distinction takes into account the limitations of paint, brushes, and especially paper. What it comes down to is this: Making a painting is simply another name for making decisions, choosing to paint what best enhances the artist's original concept.

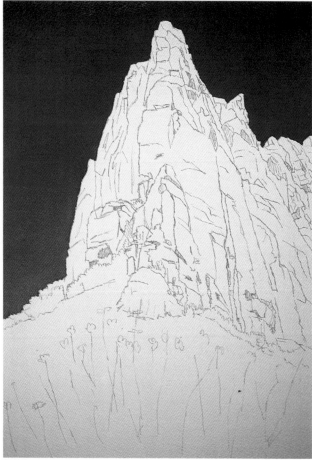

Step 1

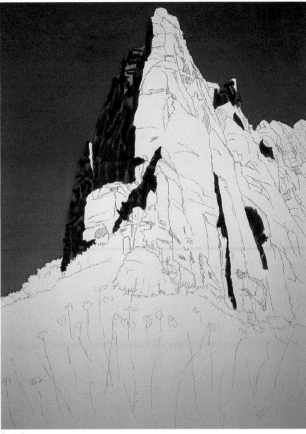

Step 2

Step 3

Step 1. To start, I used my pencil to draw in one small, representative corner of the park and allowed *that* to become a symbol for the whole. A bed of wildflowers provided me with a gentle foreground with which to introduce the eye to the background peak. I mixed a dark wash, using mostly cobalt with just a little burnt sienna as a darkening device. Since I wanted a fairly bright blue sky, when the blue began losing its intensity, I had to stop adding burnt sienna. Turning my paper upside-down, I used a second, lighter wash of this mix and began to apply it to the *top* of my paper, gradually adding the darker wash to it. Then, the paper went right-side-up again!

Step 2. I began painting the shadowed side of the peak first so that I could find the various protrusions that say "mountain" and determine my dark—to which the rest of the values were keyed. To retain the hot intensity, I used a base color of pure burnt sienna, diluted only with water. The first dark was a heavy mix of burnt sienna and cobalt. My darker dark was a thick combination of cobalt and burnt sienna. Painting the shadowed side wet-in-wet let the forms blend together somewhat.

Step 3. Using the same base color, pure burnt sienna, and a second, more diluted version of the same color, I added my standard two darks (burnt sienna and cobalt for my lighter dark and cobalt and burnt sienna for the darker dark). Then I began creating form.

At this point it became obvious how the darks of the previous step enabled me to handle this step more easily. They kept reminding me of the range of values available and of the direction of the light. Occasionally, I sneaked a reflected light back into a shadow area to help turn a corner or to prevent it from getting lost.

Step 4. First, I carefully frisketed out the flower heads, using Miskit. So that the flowers wouldn't appear too mechanical, I deliberately introduced some irregularity during this step. Next, I cut a thin strip from a scrap of watercolor paper. I dipped it into the masking liquid, wiped off the excess, and used the edge to stamp the stems and the foliage. When that was dry, I used a bristle brush and Miskit to spatter the flower area and suggest tiny flowers that tied the area together. When the masking was dry, I painted in the background tones over the frisket— warm mountain tones at the top of the area and greenish foliage colors at the bottom. Masks off!

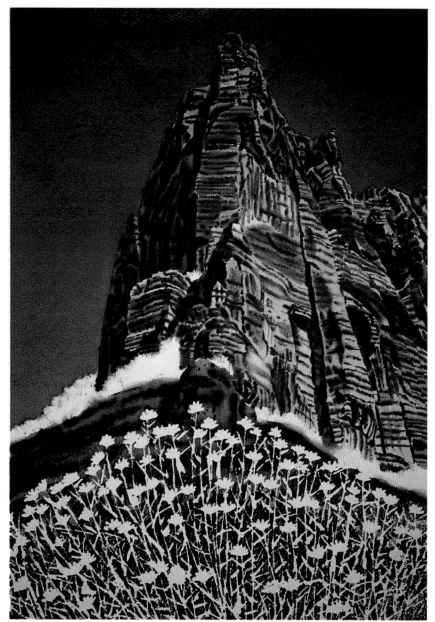

Step 4

Step 5

Step 5. The middle-ground shrubbery was painted with the same colors I used for the foliage behind the foreground flowers but a little lighter. I cleaned up the stems where they seemed too clumsy, though a certain lack of precision lends character. This closeup shows the flowers and stems before the edges were softened. Notice how they appear to be cut-out, pasted down, and very two-dimensional.

Step 6

Step 6. With a small bristle brush, I carefully softened some of the edges on each flower. Immediately, the flowers appeared more three-dimensional. But I had to be careful not to destroy the handsome, ragged edges I had worked so hard to achieve with my stamping process.

51

Step 7. When all my other values were in place, I was able to determine what tones to paint my flowers and foliage. First, the flowers got an underpainting of pure raw sienna, greatly diluted, and the leaves got one of pure olive, also greatly diluted. Then I used diluted versions of my darks to provide modeling for the flowers.

Finished Painting. A little softening here and there, some tightening up in spots, a little brighter color here, some duller color there—and it's time to invest in a frame! But before I make any rash purchases, I carefully check to see if I've accomplished what I set out to do.

I had chosen a prominent peak that provided me with the recognizable sense of place I was after, a peak that shouts "Zion National Park!" I simplified my handling of the mountain and, especially, retained the wet, watercolor look I so love. I provided a complex overall texture for the foreground, a texture that doesn't trap the eye but instead entertains it and leads it to the peaks. And finally, I painted those peaks with strong contrasts, both in value and in color—in order to *keep* the viewer's eye there. Now for that frame. . . .

MONOLITH, *watercolor, 15" × 11" (38.1 × 27.9 cm). Collection of Rick and Lu Ann Suarez.*

Your opinion for this book would be most helpful to us. Please take a moment to fill out this card.

Title: _____ Author _____

What did you like (or not like)?

What did you find most useful?

Bought at _____

Would you like a FREE catalog of all our publications? ☐ Yes ☐ No

I am primarily interested in ☐ art instruction (AB WG00)
☐ graphic design (DB GD00)
☐ architecture/interior design (DB WH00)
☐ photography (PB AM00)
☐ music (MB BB00)

Please initial if you can be quoted _____

Your profession _____

Name _____
Address _____
City/State/Zip _____

Creating Atmosphere and Space

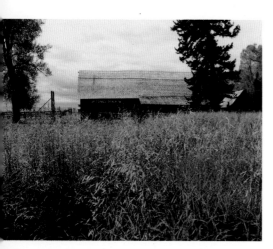

5 There were already a number of visitors in the gallery that afternoon when I noticed one thin, good-looking young man studying each of my paintings very intently. He seemed to be enjoying himself so much that I was determined not to disturb him. After looking at the last painting, he walked straight over to me, pointed to a small watercolor, and said, "I'll take that one."

Since customers are rarely that decisive, I was surprised and pleased. I took the painting from the wall and motioned him to my desk. Halfway there, he suddenly wheeled around, walked across the gallery, and came striding back with a second painting.

I was almost finished with the bill of sale when I looked up and he was gone again. He removed a third painting from the wall behind my desk and announced, "I'll take this one, too."

Rarely does anyone buy three paintings at one time, so I was delighted that he liked my art that much. My delight became a pleasant surprise when I discovered that this nice young man was the youngest son of the late Malcolm Forbes.

Eventually, Tim and I became good friends, and he not only bought more paintings but commissioned a number of them as well. *Malcolm's Barn* is one of them.

"But I don't take commissions," I protested.

"It wouldn't really be a commission," Tim argued. "You could go wherever you want and paint whatever appeals to you. If I like it, I'll buy it!"

Well, the Forbes' land is private property, and I realized that this was the only way I could get to see my Tetons from that point of view. "Okay," I agreed, "but my gallery gets to sell anything *you* don't buy." We shook hands on that, and this painting—and our friendship—grew from there.

In this scene, the viewer is facing away from the Grand Tetons, and the Gros Ventre mountain range is in the background. You realize that the farther away something is, the more "atmosphere" (haze, fog, smoke, moisture, bird droppings) exist between it and you. Since the sky represents a hundred percent atmosphere, the things farthest away are almost pure "sky color." I used the hay in the foreground as a framing device and converted the color change on the hay into a diagonal shadow to make my composition more dynamic.

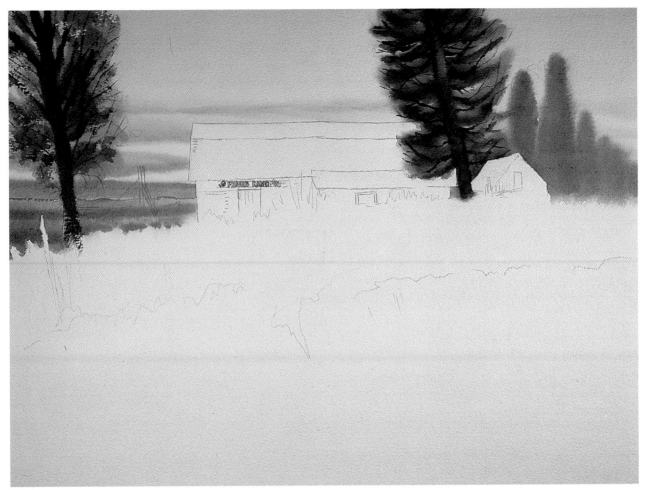

Step 1

Step 1. First, I used a one-hair brush (#1 or #0) and masking liquid to carefully paint out the lettering on the side of the barn. Then I used masking tape to protect the edges of the two barns and their roofs. Since I wanted a light, quiet sky, I planned to use only two values. I premixed a light base color of cobalt and a raw sienna, and then I mixed my darker tone, a still fairly light value of cobalt and burnt sienna. I also premixed two values of green for the middle-ground strip of grass at left center. The lighter tone was raw sienna, olive, and cobalt, and the darker tone was olive and cobalt. Finally, I premixed the dark green colors for my trees, two values of olive, cobalt, and burnt sienna.

Making sure my board was horizontal, I double-wet the entire top of my painting and I painted my lighter sky color in horizontal streaks, allowing whites

to peek through near the horizon. Into the lighter tone, I painted my darker cobalt and burnt sienna tone. I also used the darker sky color to suggest the far-off mountain range. While the paper was still quite wet, I began painting in the soft-edged background trees at the right. (This is a good time to remind you that when you're painting on wet paper, always plan a logical sequence. Whatever you put down first will be on the wettest paper and so will spread the farthest.)

Next, I underpainted the trees that were closer with my lighter tree color. As the paint became damp, instead of wet, I began adding the darker tree color. I laid in my middle-ground without worrying about a hard edge since I knew the fence would cover that up. Finally, I removed the tape, leaving a nice clean edge for my barn.

Finished Painting. The old fence was painted over the middle-ground fields with single drybrush strokes of cobalt and burnt sienna. Using drybrush is the best way to say "old wood." And since I didn't want to model the fence (because I wanted it to stay in the background), the ragged texture of that edge became critical. The large shadow segment of the barn roof was painted with a light wash of raw sienna and cobalt—with extra cobalt added at the darker peak. Burnt sienna with a touch of cobalt created the effect of rust on the roof. By painting the lower-right side of the main roof darker, I was able to lose it a bit against the foliage. That allowed the light roof of the smaller building to pop. The barn itself was painted a rich burnt sienna—in sections so that I could buy time to get around all the irregular shapes. While the paint was still wet, I added a burnt sienna/cobalt mix for shading. The dark horizontal lines of the siding on the barn were drawn with quick strokes of a ruling pen and my burnt sienna and cobalt mixture. (*Caution*: When you use a ruling pen— especially over rich color—it's important not to hesitate. If you do, the color will spread as quickly as cranberry sauce over Uncle George's new tie.) After removing the Miskit from the tiny lettering, I did a bit of retouching on some of the broken letters with opaque white and a touch of raw sienna.

The hayfield, too, was painted in sections and the base color for the sunlit part of each section was pure raw sienna. While the wash was still wet, I added my darker tone—raw and burnt sienna—and then my darkest tone—raw sienna, burnt sienna, and olive. The darker, bottom, of the hayfield also started out with a very wet base color of pure raw sienna. Into that I added a spooky mixture of olive, burnt sienna, and cobalt—and I continued painting grass forms until the wash was almost dry. Then I dragged linear tones connecting the lighter top half of the hayfield with the darker bottom. With my ruling pen and the cobalt and burnt sienna mixture, I used a broken, scratchy line to suggest the irregular roof texture. Finally, I used the same color to create the cast shadow over the light lettering. (*Caution*: I used a very dry brush and I mixed the color a value darker than I expected it to dry.)

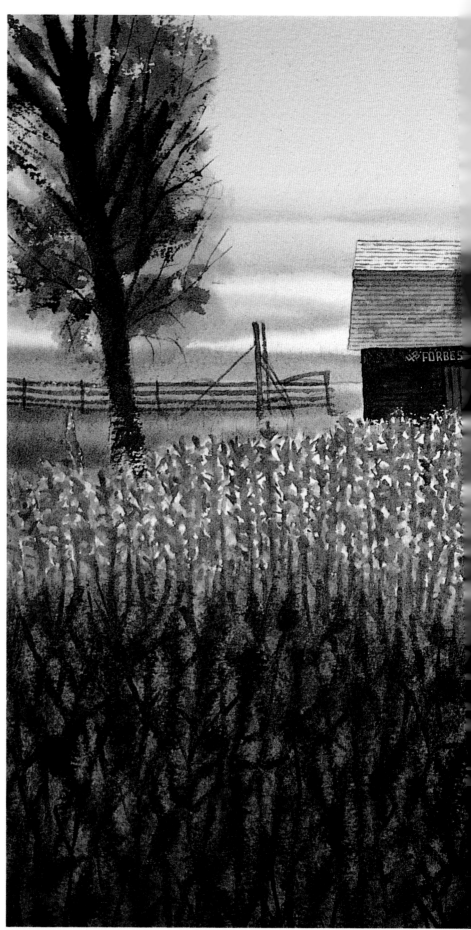

MALCOLM'S BARN, watercolor, 10¾" × 14¾" (27.3 × 37.4 cm). Collection of Timothy Forbes.

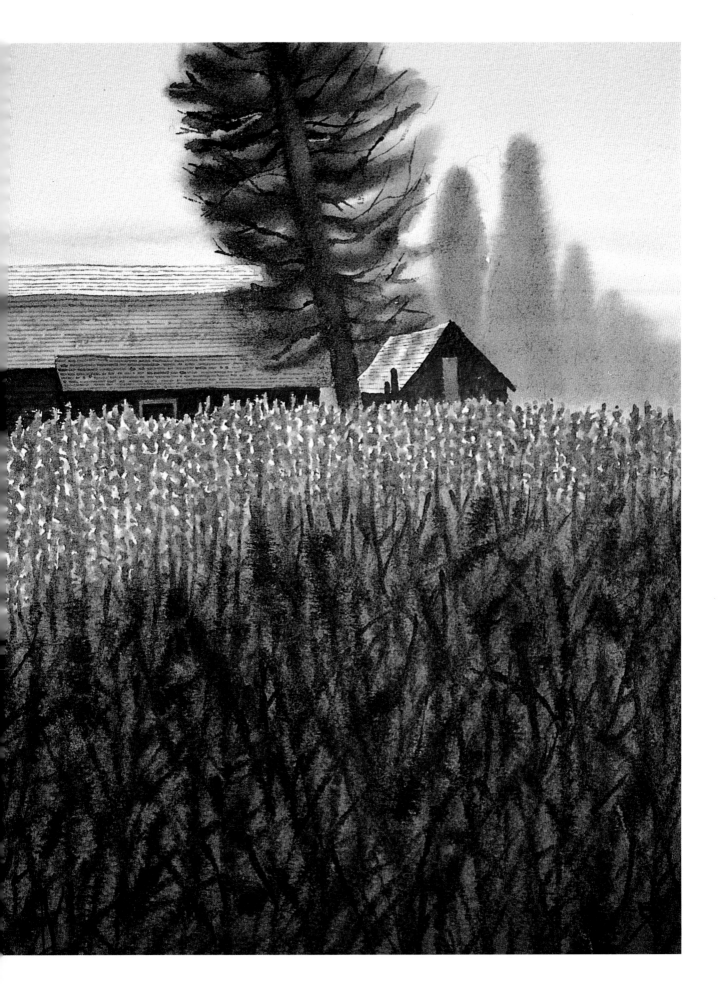

Depicting Shoreline and Surf

Quaint, tiny Harbour Island in the Bahamas is as beautiful as it is unusual. Because it is composed of coral, it has the prettiest pink beach in the world. The beach would have stretched for miles and miles except for one little fact: Harbour Island is only about a mile long and two blocks wide.

Harbour Island is an outer island off the shore of one of the main outer islands, Eleuthera. The channel between the two islands is reputed to have the most sharks per square inch, anywhere! And that's the good news!

The bad news is the usual. Cargo ships, particularly oil tankers, have chosen to clean their holds in that particular channel. On the beach near each resort, there is a two-gallon dispenser of kerosene—in order to clean the black tar off one's feet before entering a hotel!

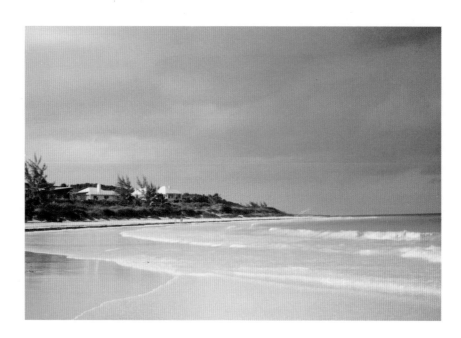

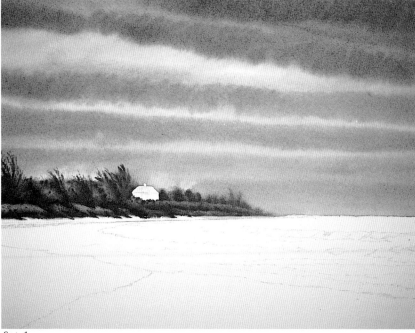

Step 1

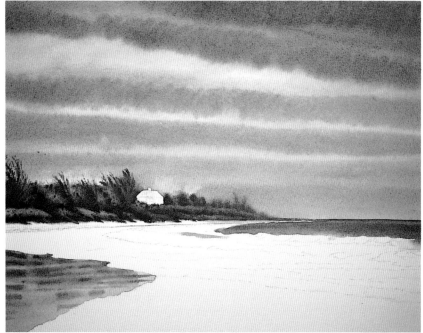

Step 2

Step 1. Because of the simplicity of this composition, and because I wanted many of the edges to remain soft, I didn't clutter up the white paper with pencil marks that would be difficult to remove later. I eliminated all the houses except the little white house, my center of interest, and I allowed extra space for the sky. For the same reason, I removed the two tiny figures.

I taped all four edges of my watercolor paper with masking tape. Since I would be working quite wet, I didn't want wet paint to sneak into dry paint and create ugly flowers in the sky. I next painted out the entire building with Miskit.

Before beginning to paint, I premixed all the colors I'd be using for my first step and made sure my drawing board was perfectly horizontal. Then I double-wet the entire top of the painting, clear down to the shoreline. Into that, I floated a very light wash of pure raw sienna, spiked with a few drops of glycerin. My premixed sky color was cobalt and burnt sienna in two different values. I painted the lighter value over the entire sky area, except for where I wanted the lightest streaks to shine through. While my first sky tone was still pretty wet, I darkened it in places with my darker value. When everything was no longer wet—yet was still quite damp—I mixed pure olive with water to begin painting the foliage at the left. Using my basic darks—burnt sienna and cobalt, and cobalt and burnt sienna—I modeled all the foliage and the grass. When everything was dry, I peeled the Miskit off.

The "northern lights" effect that occurred as the bottom of my sky began to dry was a happy accident that I decided to make a permanent part of the painting.

Step 2. For the foreground beach, I mixed a light wash of raw sienna, olive, cobalt, and burnt sienna—my four colors. Then I mixed a dark, greenish wash using the same four colors—but heavy on the olive and the cobalt. (I mixed a greenish color because the only colors I have to reflect are from the foliage and the sky.) I double-wet my paper and began painting.

For the background water, I mixed a soft blue-green using cobalt and olive. While the wash was still wet, I added reflections made from my darkest sky color, the darker version of my four colors.

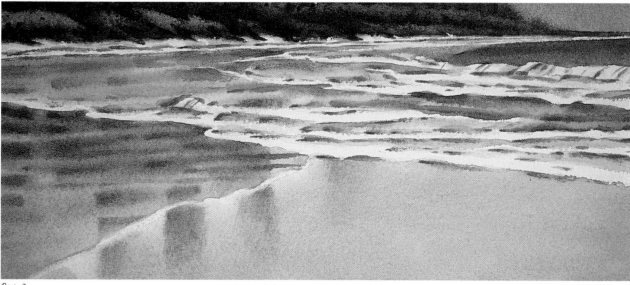

Step 3

Step 3. In this closeup of the surf, you're able to see how I used all the strokes watercolor has to offer—wet-in-wet, hard-edged, drybrush, semi-drybrush—and a few that no one's thought up a silly enough name for yet. This area would be boring without it. Remember that water reflections form a vertical pattern unless they're disturbed —and the degree of disturbance is what determines the variation from the vertical. Notice how each individual texture handles that disturbance differently.

Step 4. I made good use of the orange stain created when I removed the Miskit from the house earlier—I decided to use it as the *underpainting* for the house. By simply washing a light tone of pure cobalt over the shadow side of the house the natural vibrations between the orange stain and the cobalt (orange's complement) did all the work. The greenish color for the foreground sand (all four of my basic colors) was the first of my deeper shadow tones on the house. This went under the eaves, and it indicated the windows, chimney, and edge of the roof. I sneaked up on this one by applying the paint as a series of light washes. The final, darkest tone was the same dark bluish-gray color (cobalt and burnt sienna) I used in the sky. As the final touch, some judicious scraping with an X-Acto knife reclaimed the white edges and removed all color from the lighter side of the house.

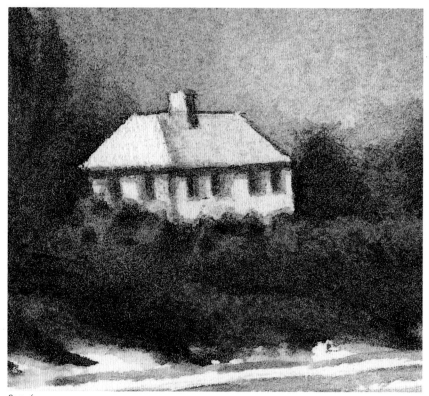

Step 4

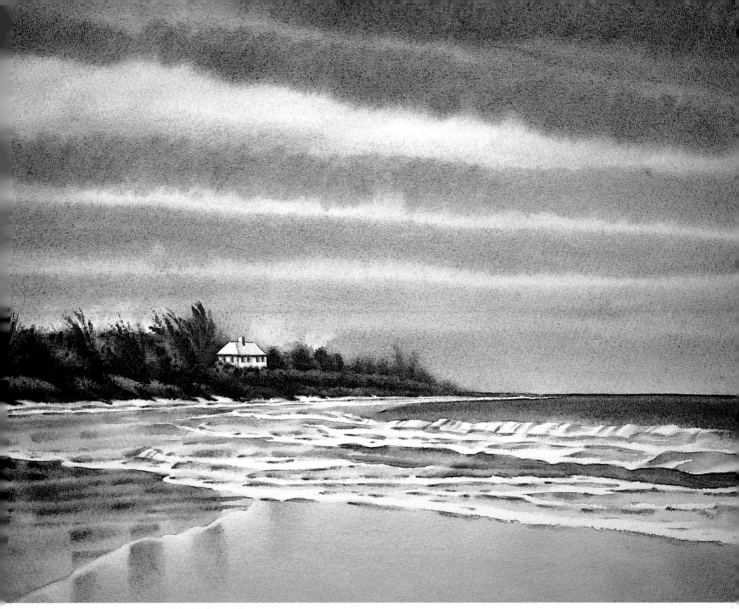

ISLAND BEACH HOUSE, watercolor, 11¼" × 15" (28.5 × 38.1 cm).

Finished Painting. The surf is
an important part of this composition,
and has to be painted rather carefully.
"Carefully" does not mean "tightly"; the
brush should still be moved with the
same quick, confident strokes. "Care-
fully" *does* suggest major consideration
before the brush hits the paper. The
surf is various tones of the bluish-gray
sky color (cobalt with a little burnt
sienna) mixed at times with the blue-
green (cobalt and olive) I used earlier.

Modeling Clouds

Sometimes you've got all your steps well planned, but the watercolor doesn't seem to gel. Something's missing. That's the time to go back to basics in order to analyze what's wrong. Be objective—even if it hurts. Then do something about it! Occasionally, the changes must be so drastic they may change the entire concept of the painting. But be strong, be creative, and don't shut any doors.

We were on an early evening jet that had just cleared the cloud cover. Being in the sky altered the normal light/dark relationship of the sunset—and created beautiful patterns and colors of its own. This looked like an easy one. Boy, was I wrong!

Step 1. I premixed all my colors. First, I needed a diluted wash of pure raw sienna as an underpainting to suggest the hot glow of a sunset. The base color of the sky was cobalt mixed with one of the auxiliary colors, alizarin crimson. (Remember, a little dab'll do ya!). My first dark was a warm mix of burnt sienna and cobalt blue, and my darker dark was cobalt and burnt sienna. After double-wetting the entire sky, I washed in my raw sienna underpainting over the upper sky area. With my very first strokes of the base color, I began modeling the clouds. To be convincing clouds have to be painted in perspective. The closer the cloud, the bigger it is; the close clouds overlap the farther clouds; and the color and the contrast have to be strongest in the foreground, gradually fading toward the rear.

Remember also—to suggest a sunset, the colors have to be brighter and more contrasty than usual. So, while the painting was still quite wet, I added a generous dollop of my first dark—burnt sienna and cobalt. This is the color that created the glow, but it can also create mud. To prevent this, I made sure the mixture leaned heavily toward the warm side—and I didn't mess with it too much. Finally, I added my darkest dark—cobalt and burnt sienna—to form the bottoms of the clouds.

Step 2. The lower sky received the same basic colors but in different positions. Mainly, the raw sienna underpainting had to be intense and apparent. Although the upper sky was composed of cumulus clouds, I still had to remember both my linear perspective and my aerial perspective.

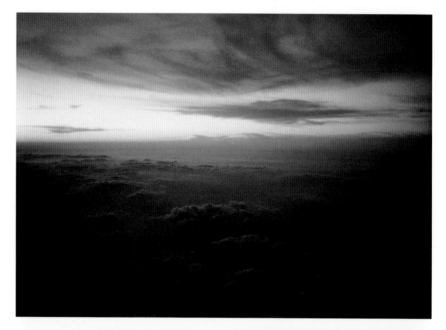

Step 1

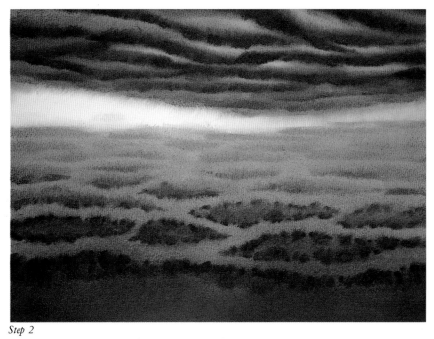

Step 2

Finished Painting. I felt the painting seemed too realistic for an abstract painting and not realistic enough for a realistic painting. It needed something. A stronger center of interest. Bingo! What better than an airplane?

Using a tracing from a photo of a jumbo jet, I shifted it around until I found the ideal location. Then I placed a piece of acetate over the tracing and created a template. (To cut the acetate, scratch the surface with an X-Acto knife and bend.) I used the template with a damp sponge to remove all the sky color from that area by blotting and cleaning the template every two or three strokes.

Using the colors I used for the sky, I painted some simple, contrasty shading on the jet. I also added a hint of pure, raw sienna. A little clean-up with an X-Acto knife, and I think it'll fly!

The 7:30 Out of Atlanta, watercolor, 11¼″ × 15″ (28.5 × 38.1 cm).

Painting
Light
on Water

Like so many of the beautiful parks not far from Los Angeles, Abalone Cove in Palos Verdes combines the beauty of the ocean and the rugged coastline with superlative weather—and flowers everywhere. The evening fog gave me the opportunity to obscure the straight line of the horizon and use the sparkling reflection of the setting sun as my center of interest. I cropped out much of the uninteresting foreground in the photo. The imbalance of the many diagonals I treated by simply tilting the clouds in the opposite direction, thus creating a foil for them.

Step 1. My center of interest, the glistening light on the water, had to be a soft yellow. For this purpose, I under-painted the entire piece of paper with raw sienna. Since I wanted the rest of the painting to have a definite purple coloration, I had to make the purple bright enough to compensate for the raw sienna's dulling effect. At this point, I want to mention the value of testing swatches. I always keep small scraps of the type of paper I'm painting on near me as I work. In that way, I can test the color reactions I might get in my paint-ing and also check the effects of the under-painting on my color choices.

 To attain the glistening effect, I began by using Miskit. I poured a little onto a piece of paper and let it dry a bit, then used the drybrush technique to apply it to my paper. I held the brush parallel to the paper and used quick short strokes.

 In using two different dilutions of the same color—cobalt, alizarin, and a spot of burnt sienna—over a raw sienna underpainting, I knew that the more I diluted my overpainting, the more my golden underpainting would show through. Every time I changed the value, I'd be changing the color. I rewet the entire painting and, with the draw-ing board horizontal, began to paint in the darker tone at the top of the paper, gradually adding the lighter tone as I moved toward the center. At the center, I again added the dark tone. Before the wash dried, I used a paper towel to blot out the clouds.

Step 1

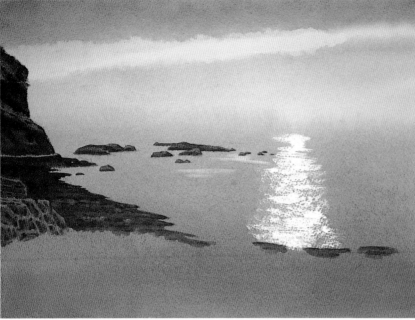

Step 2

Step 2. For the background rock and the foreground beach, I mixed a dark, warm gray of burnt sienna and cobalt. A diluted version would work for the lighter, horizontal surfaces and an undiluted version for the vertical surfaces. The rocks and the beach were to be darker in the background and lighter (with subtle wet-in-wet detail) in the foreground. For the darkest areas, I used cobalt and burnt sienna. I scrubbed out a few lighter indications of surf and softened some of the bottom edges of rock so that the rock would appear to be sitting *in* the water.

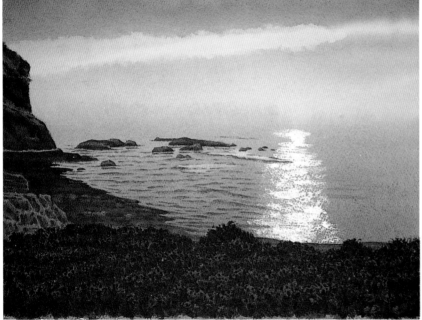

Step 3

Step 3. The base color for my shrubbery was a fairly dark concoction of olive, cobalt, with a pinch of burnt sienna. My first dark was a dark mix of burnt sienna and cobalt, my second dark was an even darker combination of cobalt and burnt sienna. I applied the paint with a fairly dry Aquarelle brush and an aggressive, jabbing stroke, being careful to monitor my values for the merging of water and sky. Using diluted versions of my two darks, I began "designing" the waves and some of the reflections under the rocks, making sure that I softened some of the edges of the waves to retain a three-dimensional look.

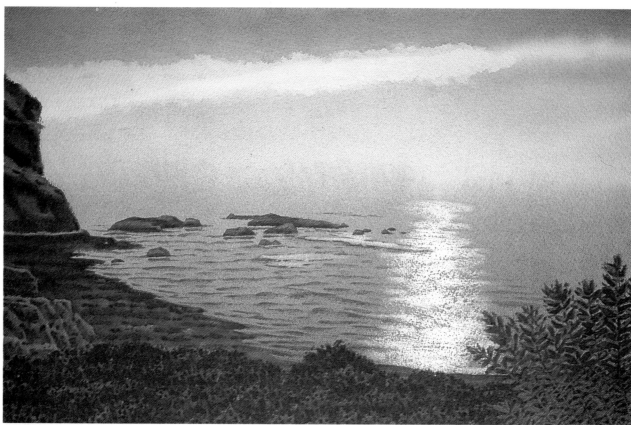

Step 4

Step 4. I darkened some tones and lightened others. I softened some edges and sharpened others. Finally, I brightened some colors and muted others. What mattered now was what the painting told me *it* needed. I took a bristle brush and softened most of the edges in the "glisten" area using subtle washes to soften them even more. I was careful to make sure that I didn't overdo it and thereby lose the drybrush feel I had worked so hard to achieve.

For the foreground shrub on the right, I used cobalt and burnt sienna to paint the dark branches. I scrubbed out leaves and branches to make them appear lighter.

Step 5. The base color for the dark foreground foliage was a mixture of burnt sienna, olive, and cobalt in two different dilutions. I made the lighter tone greener and the darker tone "redder" by varying the proportions. To create the effect of overlapping leaves, I used a template of a single leaf cut from a piece of acetate. By shifting its position after scrubbing out each leaf, I could achieve a natural look. To tint the scrubbed-out leaves, I came back with diluted washes of my leaf colors. Then I softened the reflected light on some of the rocks, center left.

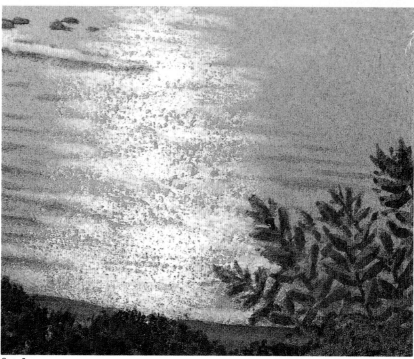

Step 5

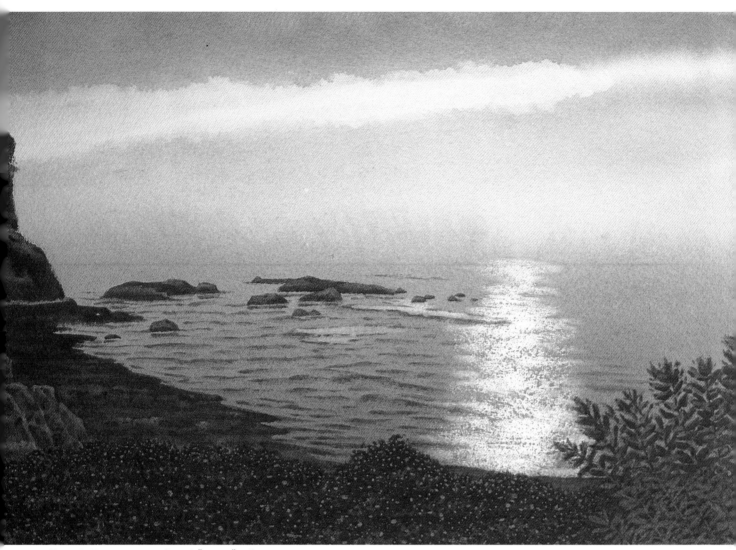

Evening Flowers, watercolor, 10¼″ × 15″ (26.0 × 38.1 cm).

Finished Painting. To liven up the foreground, I mixed acrylic raw sienna with a little acrylic white and lots of water, brought out an old bristle brush, and got ready to spatter flowers all over my foreground. But rather than risk ruining the painting, I covered it with a piece of acetate and spattered *that*. Since I liked the effect, I used an X-Acto knife to score the acetate where I wanted the paper to be exposed. Then I bent the acetate, and it cracked apart on my scored line. I repeated the spatter—onto the masked watercolor surface this time, adding a little stipple to even out the spatter; some soft washes to tone down the more aggressive stipple, and *voilà*!

Simplifying a Complex Composition

Bandolier National Monument in New Mexico presented the right combination of interesting elements for me. Expressing form and texture on a two-dimensional piece of paper is the reason I find painting in watercolor so much fun. And when the subject suggests the mystery of a primitive society struggling to carve dwellings out of the side of the mountain, that's intriguing. That these dwellings are now abandoned made them seem all the more irresistible to me. Because of the complexity of this subject, I made a pencil sketch first, very accurate and very detailed, even going so far as to indicate shading. Working out problems of draftsmanship and perspective at this stage would guarantee freer work with the brush later.

Step 1. Double-wetting my entire piece of paper, I tilted my drawing board about fifteen degrees and washed a very light, warm tone of raw sienna (with a speck of cobalt in it) over everything. When my yellow underpainting was thoroughly dry, I mixed a light wash of pure cobalt blue and re-wet the sky area. Beginning at the top (and skipping the cloud area), I brought the light blue wash downward—without reloading the brush. At the horizon, with all the blue gone from my brush, there was my original yellow underpainting.

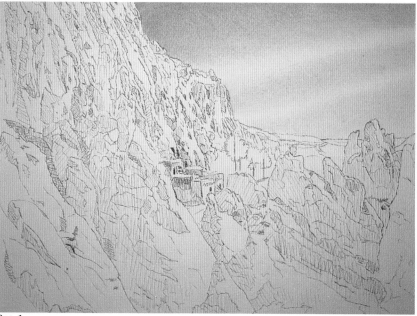

Step 1

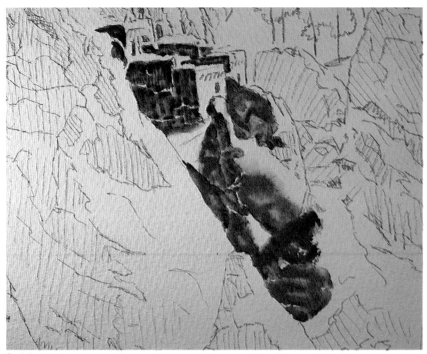

Step 2

Step 2. Since I designed the central dwelling to have the greatest contrast, I began my modeling with that and moved out from there. Because the warm base color reflected back into all the shadows, I made my first dark a very hot mixture of raw and burnt sienna. My darker dark was a fairly cool mixture of cobalt and burnt sienna.

Finished Painting. I wanted the viewer to participate in the discovery of the subject himself, so I was very careful about reducing the contrast as I moved away from my center of interest. For the trees, I used a mixture of olive and cobalt with a dash of burnt sienna. The shadow areas of the trees consisted of a few more coats of the same color. I carefully checked every tone for accuracy in terms of my tapering contrasts, then lightened some areas and subtly darkened others. When I reached the balance I wanted, I called it a day!

WHERE HAVE ALL THE FLOWERS GONE?, *watercolor, 11" × 15" (27.9 × 38.1 cm).*

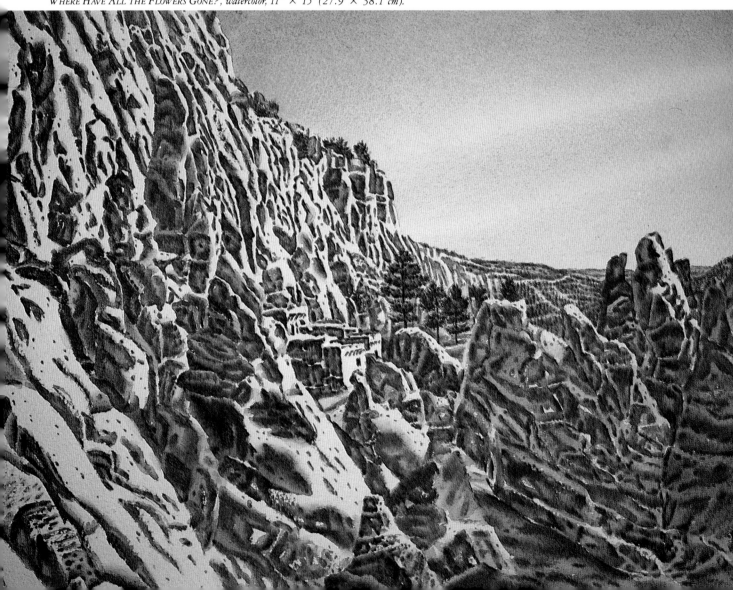

Fine-tuning a "Simple" Painting

10

Harbour Island in the Bahamas is a tiny, primitive island, two blocks wide by about a mile long, near the outer island of Eleuthera. Everything on Harbour Island had a slightly out-of-whack, handmade appearance, including the thirties' style hotel we stayed in. Somehow, the white gate and the rambling banyan tree seemed to capture the split personality of that beautiful island. Since I wanted the gate to be the center of interest, I moved it to the right to tie in more closely with the overhanging branches. Then I cropped the right side of the tree to keep it closer to the center of the painting.

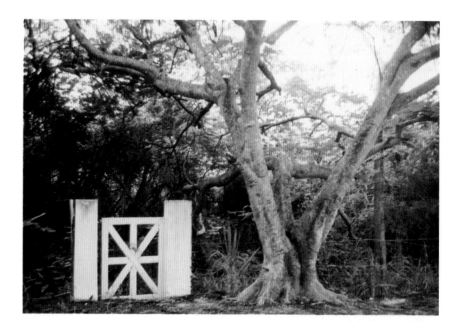

Step 1. Since this promised to be a very active painting, I had to keep in mind that the white gate was my center of interest. I began by making a pencil drawing in which I moved the old gate to the right to tie in more closely with the overhanging branches. Then I cropped the right side of the tree to keep it closer to the center of the painting.

Step 2. Using Miskit, I masked out the tree trunks and the gate. I premixed a light value of olive and raw sienna for my base color; olive and burnt sienna for my first dark; and olive and cobalt blue for my darker dark. In this painting, I also used my darkest dark—cobalt, burnt sienna, and olive. My base color for the foreground path was burnt sienna and cobalt. After double-wetting the entire sheet and leaving the trail of pure white paper across the top of the

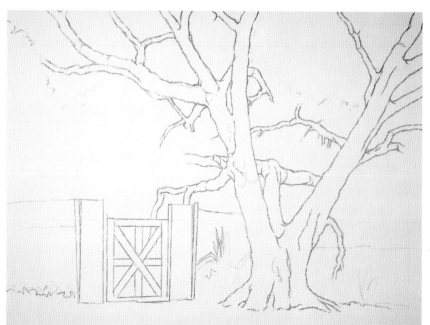

Step 1

70

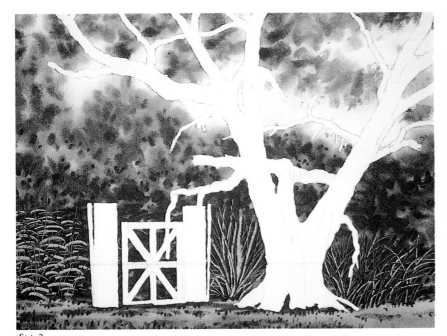

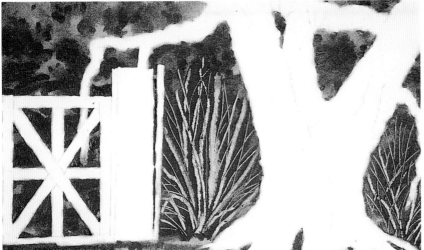

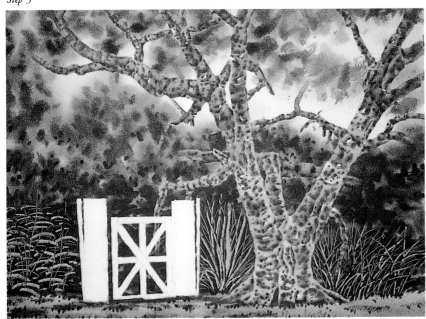

painting, I dropped in my olive and raw sienna base.

For the sun-dappled effect, I allowed plenty of the light base color to poke through my first dark—olive and burnt sienna. I added the darker dark—olive and cobalt—and then a touch of the darkest dark—cobalt, burnt sienna, and olive. I dropped in the base color for the damp grassy path, a light value of cobalt and burnt sienna, then added the same warm, lighter dark—olive and burnt sienna—and the same darker dark— olive and cobalt. Small touches of the darkest dark—cobalt, burnt sienna, and olive—livened things up. I included some short, vertical grass strokes, and I scraped some jungle-type foliage strokes, using the handle of my Aquarelle brush. When everything was dry, I removed the friskit. It's best to remove friskit by using a strip of masking tape, rolled sticky-side out, then flattened. By revolving the "roll" and patting instead of rubbing, you'll reduce the chance of smearing.

Step 3. With a stiff, bristle brush, I softened many of the edges of the tree branches, especially the ones that seemed to be turning away from me. By keeping edges soft early on, you free yourself to retain the softness or to make the edges more crisp later on.

Step 4. For my base color, I mixed a diluted wash of cobalt blue, burnt sienna, and raw sienna. My first dark was the same as before—olive and burnt sienna. I diluted the darkest dark used before—cobalt, burnt sienna, and olive—and used it as the darker dark. I painted the tree trunk and branches in sections, applying the base wash fairly dry so that the dark wouldn't ooze too much and make the branches look dark.

The white gate received light mainly from reflected sources and had no local color of its own. Instead, I used diluted versions of my warm dark—olive and burnt sienna—and of my darkest dark— cobalt, burnt sienna, and olive. I applied the lighter tone with a fairly dry, wood-grain-type stroke and added the darker tone in selected places while the paper was still damp. To tie the two elements more closely together, I painted the ground reflections at the bottom of the gate.

Finished Painting. In order to match that magic image in my mind, I increased contrast in some places on the old banyan tree and I decreased it in other places. That way, the silhouette would not appear too broken up by the busy background—yet I maintained control over the subtle lost-and-found effect I was after. Some of my last-minute moves included cleaning up edges on the fence with darker tones in some areas and X-Acto knife scraping or wetting and blotting in other areas. To exaggerate a warm/cool relationship, I bounced a hot reflection onto the right side of the banyan tree with a very light wash made up of pure burnt sienna. Finally, using the tip of a sharp X-Acto knife, I scratched in the lost-and-found hint of the wires. I hoped I had achieved the Humphrey Bogart/Edward G. Robinson sultry effect of the late 1930s that I was after. Once again, I did it by showing only a portion of something— the tree—in order to suggest the atmosphere of the entire island. But, remember, an apple tree on Harbour Island just wouldn't cut it.

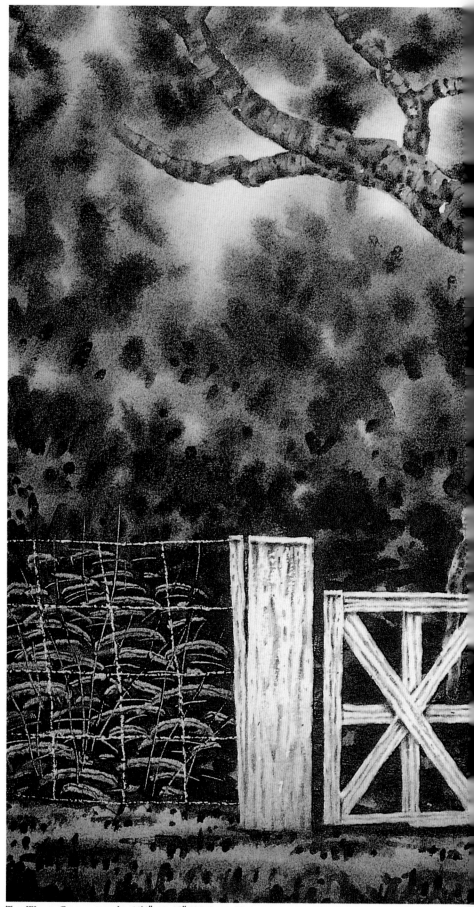

THE WHITE GATE, *watercolor, 11¼" × 15" (28.5 × 38.1 cm).*

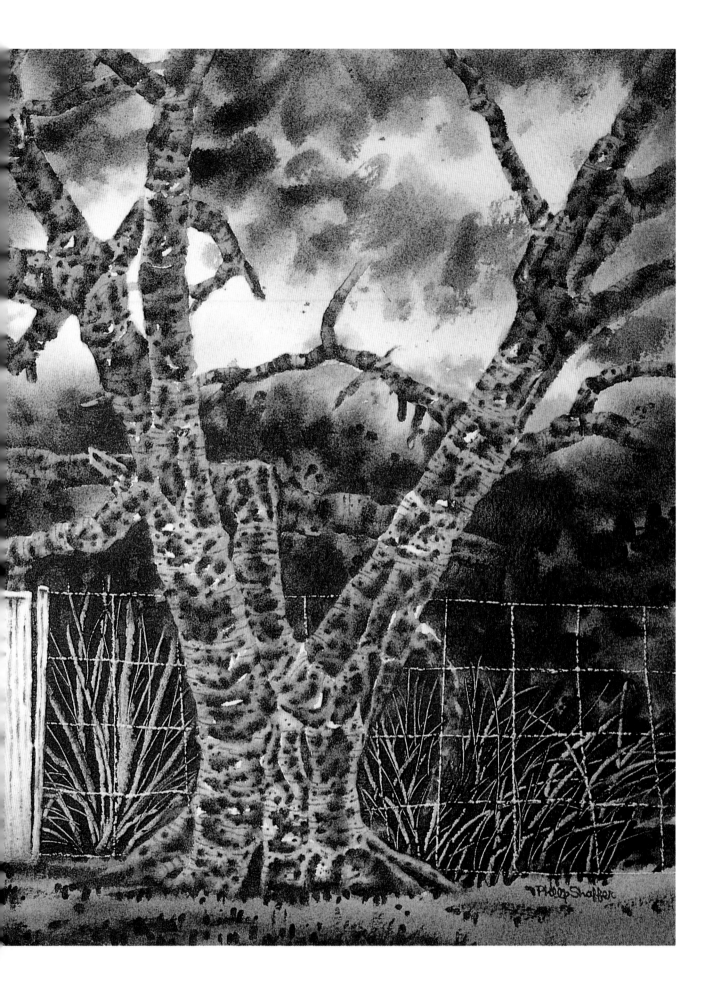

Pairing Contrasting Textures

11 In this particular scene, the contrast between the dry, crusty appearance of the old pueblo in Taos and the soft, fluttering wash drying on the clothesline created a homespun beauty that's hard for an artist to resist. To emphasize the sensuous texture, I could have imprinted the texture while the wash was barely damp by lifting the paint with crumpled paper towels, facial tissue, plastic wrap, the palm of my hand, or whatever. Or, as we shall see, there's a more controllable way.

Step 1. On a piece of Arches rough watercolor board, I penciled in the old building and various other elements.

Step 1

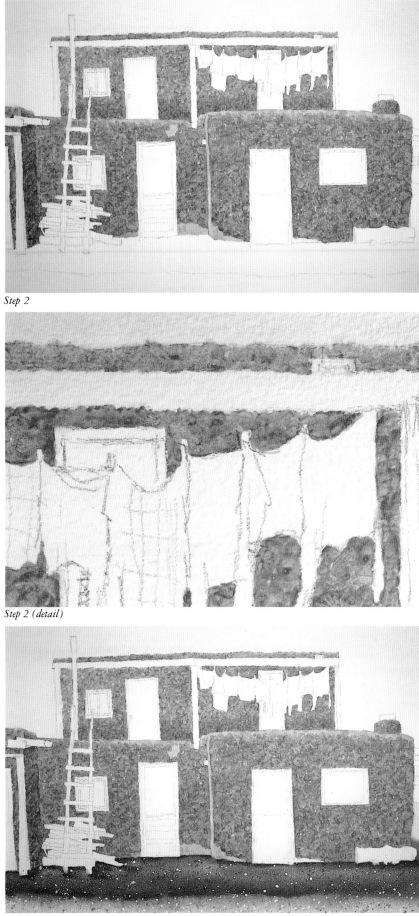

Step 2

Step 2 (detail)

Step 3

Step 2. I wanted to leave a white sky, but it would have created so much contrast that the silhouette of the building would have become more important than the texture. Instead, I mixed a very diluted version of the raw sienna, burnt sienna, and cobalt, and wet the board before beginning my watery wash across the top. I kept adding water all the way down. Using raw sienna, burnt sienna, and cobalt, I mixed my medium-value color to use on the pueblo itself. And this is the way I obtained texture more controllably. I scrubbed a brush loaded with this color onto a bar of soap until I had a thick mixture. Then I painted the pueblo walls with a jabbing stroke. Because the paint was so thick, it would stay exactly where I put it. Adding more cobalt or burnt sienna created the darker areas, the cast shadows, for example. Blotting worked beautifully for the lighter areas.

Step 3. With a sheet of tissue and some masking tape, I masked off the area from the bottom of the pueblo up. Using my stiff-bristled nylon brush, I spattered Miskit masking liquid into the remaining area to mask out where I wanted the rocks and gravel to be. When the friskit was dry, I painted a diluted warm gray wash (burnt sienna and cobalt) over this area, avoiding the foreground log and rocks. For the cast shadow, I painted a medium-dark value of burnt sienna and cobalt into the wet area. In the shadow color, I placed the cool, darker dark—cobalt and burnt sienna. Then I added an even less diluted version of this color for the shadows within the shadows. To suggest more rocks, when all was dry, I spattered the area with a lighter version of both darks. Then I removed the Miskit.

Finished Painting. To make the rocks and gravel stay put in the shadow area, I used a damp brush to kill the harsh whiteness of the paper. I dabbed a spot of my cool dark color under and to one side of each rock. I painted the wooden doors and various wood panels a warm gray of burnt sienna and cobalt and the windows a light, neutral gray of cobalt and burnt sienna. The chunks of firewood were begun with a cool gray base of cobalt and burnt sienna, warmed in places with pure burnt sienna, and shaded and grained with dark cobalt and burnt sienna mix.

I painted the trim of soft aqua color—a mixture of a diluted cobalt blue and a bit of olive green. To keep the clothesline bright, I painted the clothes with diluted versions of pure cobalt, pure burnt sienna, and pure raw sienna. To tone down the shirt on the far right, I used all three colors. With various darks, I introduced holes, cracks, pitting, and grain into the weathered wood. Then, with a touch of opaque white, I added highlights and edges to my wood colors. The fine tuning of this "simple" painting was a balancing act that took more time than any of the other steps.

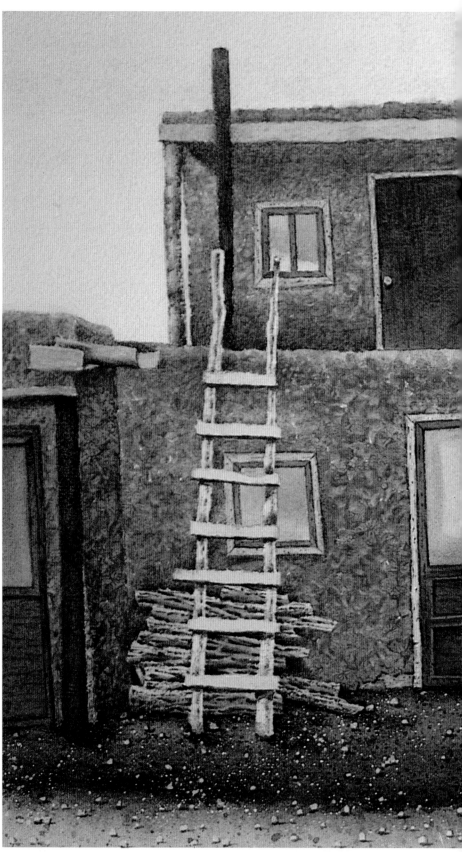

ADOBE MONDAY, *watercolor, 9¼″ × 14¾″ (23.5 × 37.4 cm). Collection of Pam Kearns.*

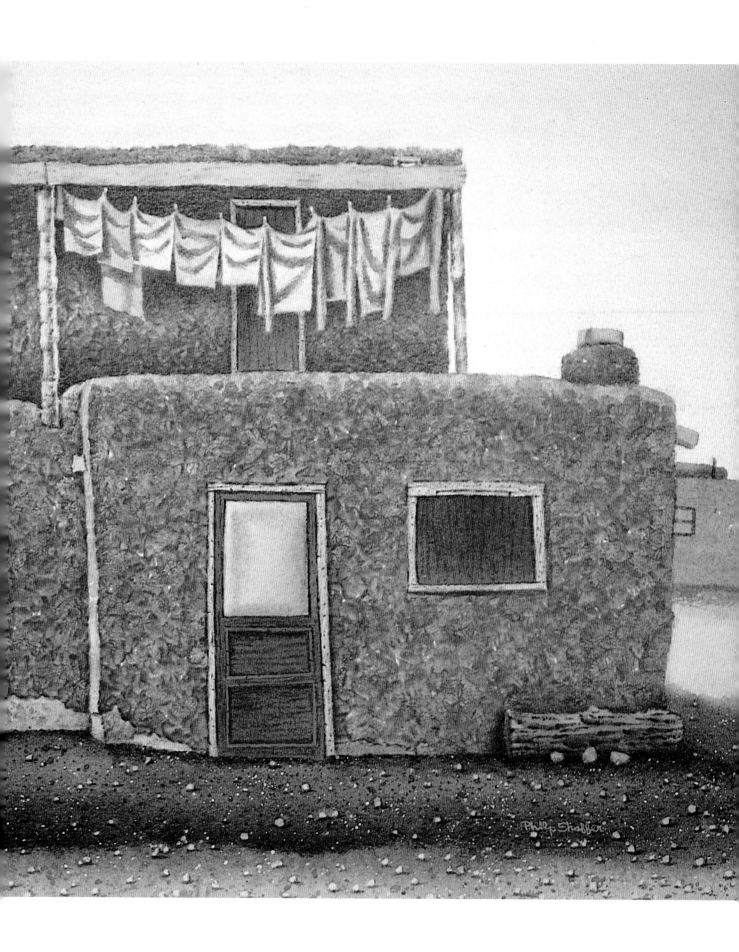

Establishing Scale with Figures

12

The Grand Canyon is an immense, awe-inspiring, color-saturated, just-plain-old-gorgeous phenomenon. This particular corner of the canyon, Moran Point, is named after Thomas Moran, America's greatest landscape painter, who frequently painted the Grand Canyon. It was Moran's majestic paintings, brought back with the Hayden Expedition (1872), that determined that Yellowstone National Park would become the world's first national park. For my painting, I wanted to introduce a single, tiny figure into the composition and then lose him a bit in order to suggest the sense of insignificance everyone feels when viewing the canyon.

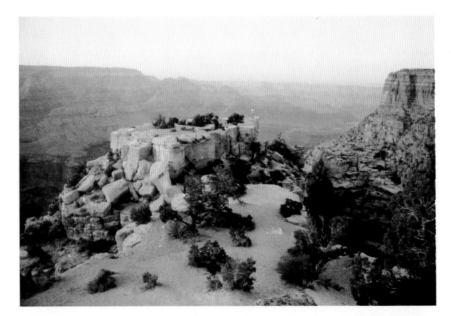

Step 1. To keep my center-of-interest white initially, I masked out the little guy with liquid friskit. Since the lightest tones in the painting were to be the tops of the cliffs and the sky, I proceeded via the layering process, first painting a light wash of pure raw sienna over the entire piece of paper. When it dried, I mixed a light wash of alizarin and cobalt, turned the paper upside-down, and painted the entire sky and distant background area. When that dried, I mixed a light wash of pure cobalt, and, with the board right-side-up again, began painting at the top of the sky, adding water as I worked my way down, finally losing all color by the middle of the sky.

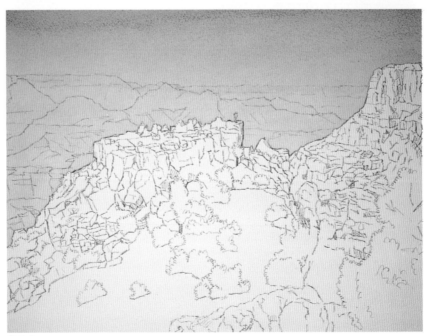

Step 1

Step 2

Step 2. I applied another light wash of pure cobalt over the distant cliff area, which separated the cliffs from the sky. I used a piece of paper towel on the wet surface to blot out the lighter areas of the cliffs at the top left. A second layer on all but the most distant cliffs was composed of cobalt with a touch of burnt sienna. To make my task more manageable, I worked in sections, and as I worked my way across the cliffs, I lightened occasional highlighted areas with the ol' wet-and-blot routine.

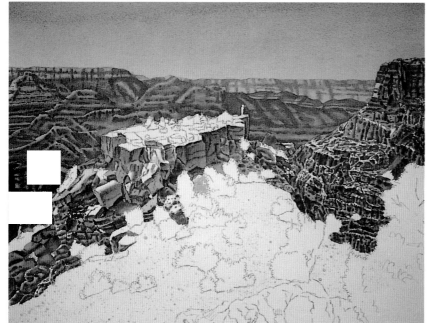
Step 3

Step 3. With the standard mixtures of my two darks (burnt sienna and cobalt for the lighter and cobalt and burnt sienna for the darker), I finally modeled the distant cliffs, trying to retain the mysterious lost-and-found quality of the plateaus. At this point, I removed the friskit protecting my mini-man.

Step 4

Step 4. I used a fairly hot mixture of raw sienna and burnt sienna for my base color. The first dark was burnt sienna and cobalt (a lot of the former and a little of the latter). The darker dark was the usual cobalt and burnt sienna. As I modeled each cliff wet-in-wet, I kept in mind the direction the light was coming from and shaded accordingly. I spattered rocks into the immediate foreground with my masking liquid. If you use this technique, remember to protect the remainder of the painting—and yourself—when you spatter.

Step 5. I mixed a slightly cooler and a slightly darker version of my raw sienna and burnt sienna base color by adding cobalt. This was my *new* base color; my two darks would remain the same. After wetting the paper in the immediate foreground, I dropped in my new base color. Moving from left to right, I lightened my base with more water and cooled it off with more cobalt. When everything was no longer wet yet still damp, I added my long, cast shadows, plus a bit of spatter. With a stiff brush, I softened most of the edges where my foliage would overlap the rocks; I didn't want those edges to come back and haunt me! Finally, I removed the Miskit spatter.

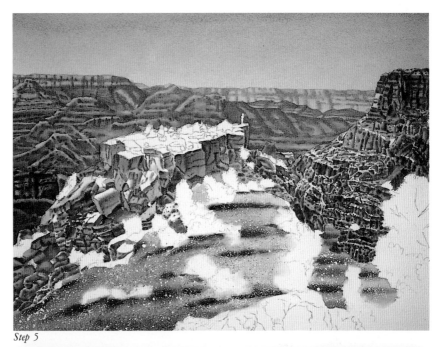
Step 5

Step 6. I rubbed a damp brush over the raw Miskit-spattered rock area to tone down the rocks. I only wanted them as a device to make that big, bare center area more interesting. By painting cast shadows under the biggest of the spattered rocks, I created instant three dimensions! The rich, dark foliage color helped link all the pieces together. Using my Aquarelle brush with a pushing, scrubbing-type stroke, I underpainted all my reddish foliage with a fairly concentrated mixture of burnt sienna and water. To fine-tune the abstract design of the foliage, I altered shapes, combined clumps, enlarged areas, and trimmed here and there. Finally, I used a darker tone to better define the foliage. For the larger bushes at the bottom, I scraped into the still-damp reddish foliage with the tip of my Aquarelle to create the impression of branches. When all was dry, I softened occasional edges with a damp brush.

Step 6

HYMN TO MORAN, watercolor, 11¼" × 14" (28.5 × 35.5 cm).

Finished Painting. First, I deepened some tones behind the ledge the figure was on—and behind the figure itself. I went easy because I didn't want the little guy to get lost, but I didn't want anyone to find him too easily either. I painted the tiny figure very simply, using pure alizarin crimson for his shirt and pure olive green for his trousers. To increase the contrast, I blotted out a white halo along one side.

I painted in the immediate foreground chunk of mountain, wet-in-wet, with the same colors I'd been using throughout and warmed some of the highlights on the distant cliffs with a weak wash of pure burnt sienna. Finally, I cropped the painting, which required some additional tone adjusting in accord with the new edge. A bit more softening here and there, and look out, Thomas Moran!

Using Figures to Suggest Depth

13

There's an artist who deserves credit for helping me through the years when my body was in the city and my head was in the mountains. When it seemed that a six-day workweek (five days of commercial art and one day of painting) was too much, it was John Denver, who through his art convinced me that *seven* days (five days of illustration and two days of painting) was not nearly enough. For years I've felt the impact of his music. Now I'd like to take this opportunity to thank him for his wonderful music—and to dedicate this painting to him. Far out, John!

Step 1. I made a precise pencil drawing to begin with. Then I painted only along the edges of the two figures so that I wouldn't lose my drawing when the friskit was removed.

To achieve the feeling of deep space, I decided to leave the white paper for my sky, and gradually introduce color as I got closer. After taping the edges of the painting with masking tape, I double-soaked the entire piece of paper. Then I added my base color (a very diluted mixture of raw sienna, cobalt, and a touch of burnt sienna). Using my standard cobalt/burnt sienna, diluted, I began modeling the forms as soon as the base wash dried to a damp stage. As the paper dried, I gradually increased the proportion of pigment to water, taking care not to increase the contrast too much at this point.

Remember that any wash, added to a wash already on the paper, must be as wet as the original wash. If it's too dry, it will suck up the paint already there. If it's too wet, it will spread uncontrollably. You've got a little leeway when everything is soaking wet, but the drier things get, the more critical the moisture content becomes.

Step 1

Step 2

Step 2. I darkened my original base color by adding more olive, cobalt, and a dash of burnt sienna. I continued to use the cobalt/burnt sienna mixture as my only dark. Rewetting the paper section by section, I began painting my middle ground, adding more and more olive to the base color as I worked my way down the paper. By the time I reached bottom, my base color was almost pure olive. When everything was dry, I removed the friskit and the Scotch tape.

Step 3

Step 3. Notice that my strokes became freer in the foreground. The added flicks and flecks of the looser strokes suggest more detail and, consequently, help pull the foreground even closer. At this point, I kept the rocky patches white, since it would be easier to know how far to tone them down when the surrounding tones were in position.

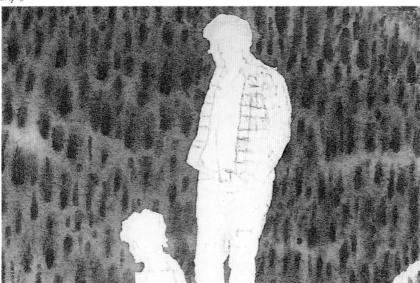

Step 4

Step 4. In this photo, you can see the advantages and the disadvantages of each method of masking. The Miskit discolored the watercolor paper. Since this area will be warm-colored anyway, there's no problem. On the other hand, Scotch's Magic Tape is so transparent that one can't always tell where it is—and where it isn't.

Step 5. To bring the foreground rocks even farther forward, I warmed them up by adding raw sienna and a dollop of burnt sienna to my base color (raw sienna, cobalt, and a touch of burnt sienna). Then I diluted it with water to get my new, lighter, base color. For the first time in this particular painting, I introduced my standard first dark, a very warm mix of burnt sienna and cobalt blue. Finally, I used a cobalt and burnt sienna for my darkest dark to separate the foreground even more and to give it the contrast it needed to remain separate.

Step 6. Another device I used to bring the foreground rock forward is detail. The eye can recognize detail only on objects that are close. Thus, if it detects detail, it assumes that that surface is nearby. Using drybrush, spatter, and stipple, I painted in every crevice and lump known to modern man until the rock finally took its rightful place as my foreground.

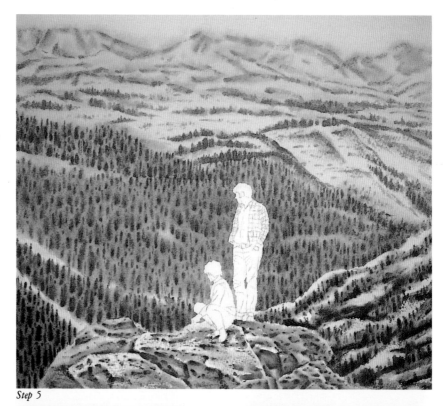

Step 5

Step 6

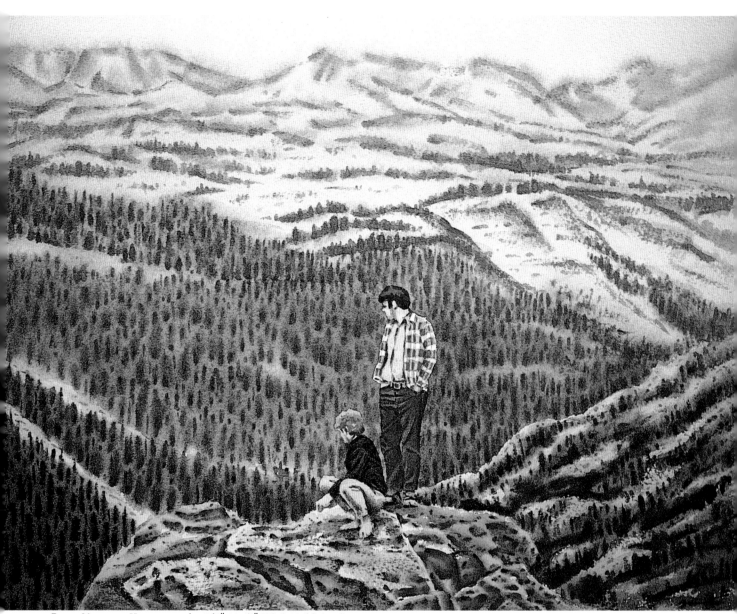

ROCKY MOUNTAIN HIGH, watercolor, 11¼" × 15" (28.5 × 38.1 cm).

Finished Painting. First I
painted the two figures with flat colors
(no shading). Since I wanted the figures
to remain as simple as possible, I barely
modeled them. Sometimes, I didn't
model them at all! In order to push the
figures forward, I made the man's plaid
shirt red, using pure burnt sienna, and I
made the base color for the lady's blond
hair a pure raw sienna.

Notice how I achieved all the deep
space anyone could possibly expect from
any palette—and I did it with only four
colors!

Preserving a Sense of Place with Textures

14 There were a number of earthquakes in Jackson Hole, Wyoming, in June 1925. But no one was prepared to have a huge chunk of Sheep Mountain come tumbling two thousand feet down one side of the mountain and then four hundred feet back up the other side. Two years later, the dam formed by the first slide overflowed, and the sudden flood wiped out the town of Kelly, four miles below. Today at Slide Lake, everything seems somehow out of whack. Trees that started out in one place are jutting, at unnatural angles, in a totally different place. Yet just a few hundred feet from all this rubble, everything seems normal and peaceful: The lake looks like any other small mountain lake, blue and beautiful. In painting areas that are familiar, I make a conscious effort not to destroy the individual sense of place each area possesses. At the same time, as an artist I feel obliged to come up with a good composition. That represented no conflict in this case because this scene practically composed itself. The minor changes I did make were in the center, far right. I extended the island farther left to break up the shoreline even more and to prevent the eye from going off the right side of the painting. For the same reason, I also made the tall evergreen taller.

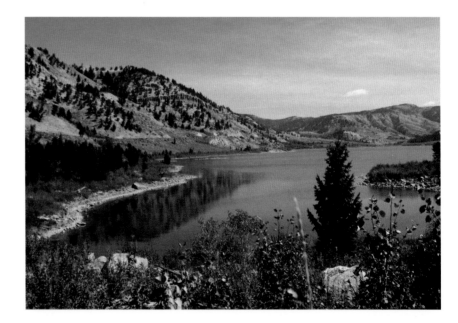

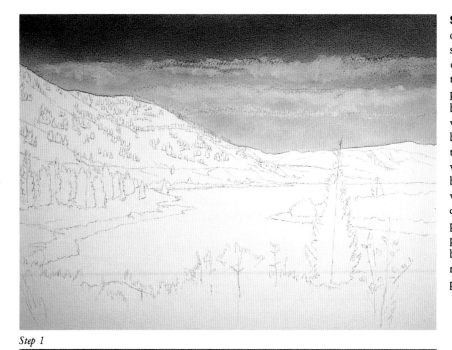

Step 1

Step 1. First, I masked off three sides of my watercolor paper. Then I added some water to my usual darker dark—cobalt and burnt sienna. (I always keep two of the slots in my mixing tray premixed with my two basic darks: burnt sienna and cobalt. I can cool or warm this mixture by adding cobalt or burnt sienna.) I began my painting with the board upside-down by double-wetting the sky area. Then, turning it back again, I washed in the sky. Since I wanted the sky to become lighter as it descends, after the first few brushloads of paint, I switched to water. While the paint was still damp but no longer wet, I blotted out the clouds with paper towels, remembering to depict them in perspective.

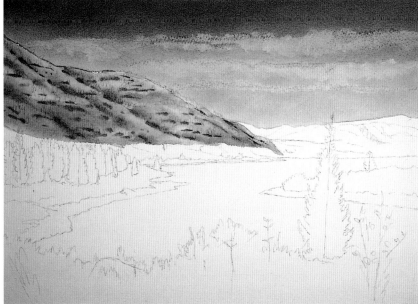

Step 2

Step 2. I mixed a grayish yellow, using raw sienna, cobalt, and burnt sienna. I also prepared a light wash of pure burnt sienna. Double-wetting the hill at left, I painted in the red clay hills with my pure burnt sienna wash. Then I was able to fill out the remaining wet area with my grayish yellow wash. When all that was set up, I began dropping in the cast shadows of some of my evergreens (olive with a little cobalt). Normally, it makes more sense to paint the object first so that I'll know where the cast shadow goes, but I wanted to get soft edges that I might not be able to get later.

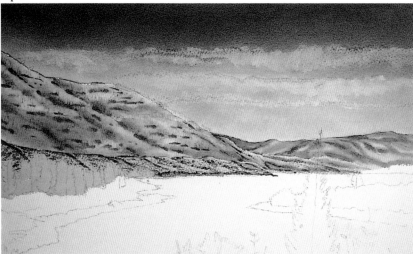

Step 3

Step 3. I diluted my yellowish mixture (raw sienna, cobalt, and burnt sienna), warming it with more burnt sienna. This new base color I used for the middle-ground hills as a flat under-painting on the left side of the painting and as a base for my wet-in-wet wash on the right side. Then I added the same dark (cobalt and burnt sienna) that I used as a cast shadow in Step 2, to shade *this* area.

Step 4. I painted the dull green of the background shrubbery at left with olive, a bit of cobalt, and a little burnt sienna. I mixed it a bit darker than I expected it to end up because I was using drybrush and the lighter background color would show through and make it appear lighter. Using the same dark green, painted over the base color—raw sienna, cobalt, and burnt sienna, and my two standard darks (diluted)—I painted in my background hills (far right) and the island.

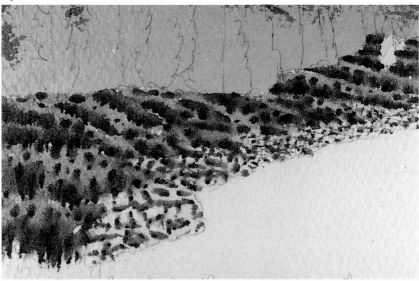

Step 4

Step 5. The foreground and the island rocky areas are much lighter, warmer versions of the same raw sienna, cobalt, and burnt sienna mix with which I underpainted the middle-ground hills. Naturally, I used the same two darks to model the rocks (same light—so same darks, right?). A little softening with a damp brush, a little scraping with the flat edge of an X-Acto knife, and I've got the rocks! I used a pure olive base, ably assisted by two standard darks, and I'm even safely past the weeds.

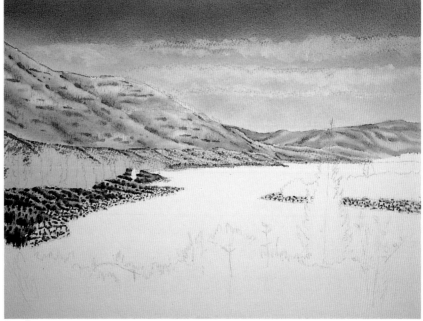

Step 5

Step 6. This is how the entire painting looked at this stage. Sometimes it's difficult to remember that each thing should have its own color, especially when you're working with subtle colors such as these. But particularly with subtle colors, when a small shift—warmer or cooler—makes such a big difference, it's important. Exaggerate colors, change colors if you must (making sure you still maintain the appropriate sense of place), or just out-and-out lie, but keep the integrity of each element by giving each one its own separate color.

Step 6

Step 7

Step 7. Beginning with a bold, base color of pure olive, I used my Aquarelle brush to push most of the tree strokes into place. While each stroke was still damp, I darkened it, first with my lighter dark—burnt sienna and cobalt—and then with my darker—cobalt and burnt sienna. Using the olive base color with a fairly dry pointed brush, I pulled the tips of some of the branches past their main mass—increasing the appearance of irregularity. Then I used a damp brush in places to soften the effect.

Step 8

Step 8. My base color for the water was cobalt and a little olive. This represented a mixture of the reflection of the sky and the reflection of the foliage. Since I needed time at this point, I added a couple of drops of glycerin. After double-soaking the reflection area, I began painting the water (cobalt and olive, remember?). As I moved downward, I gradually added my darkest dark—cobalt and burnt sienna—to the wash. I wanted the bottom of the water area to end up very dark to contrast against my light foreground weeds. I painted a rich, pure olive as the base color for my tree reflection area. I began to model the area with my two darks, finally painting in all the little "holes" between the branches with the same base color and the same two darks.

Slide Lake, watercolor, 11" × 15" (27.9 × 38.1 cm).

Finished Painting. I wet the entire foreground weed area, and into that I painted a very diluted wash of pure burnt sienna. For variation, I deliberately put more paint in some areas and none at all in others. Then, I began modeling weed forms, using more and thicker olive, trying for a smooth fade-off at the bottom and at the edges. Occasionally, I facilitated the fade-off by scrubbing gently with a bristle brush. Sometimes, I even socked in a few crisper edges with additional cobalt. On the island, the bushes and the lone tree were painted with an olive base and my two darks. I painted the foreground tree the same way, but with more contrast to make it come farther forward. Then I began painting all the trees spotted throughout the middle ground and background. While these were still wet, I added a swipe along one side with my olive and cobalt mixture to increase the three-dimensionality. I softened the edges of some of the trees with a damp brush, and I gave other trees two coats of base color to add interest. I put shadows under the remaining trees, using the same cobalt and burnt sienna mixture, and finished up with a little softening, a little sharpening, and some drybrush here and there.

Conveying Power with Wet-in-Wet

15 The rock formations of Point Lobos State Park are the most beautiful and bizarre sculptures along the California coastline. They are sculpted by the whitest, most violent surf. The surf carves unique and creative "windows" from the solid rock. These windows then become the conduits for the water that collects underground, guiding it toward its exit. There, it emerges as a foam geyser, only to begin again.

For this painting, I began with a pencil drawing in which I enlarged the main breaker, making it my center of interest. The color and contrast in the photo was kind of dull, but that was easy to take care of—as you'll see.

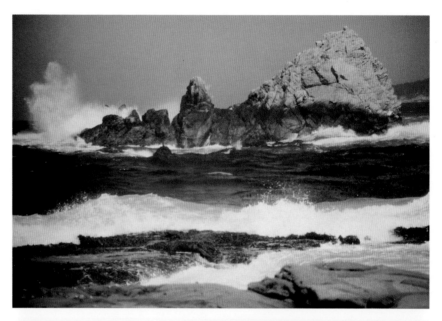

Step 1. I used masking tape along three edges of the painting to prevent my wash from creeping under the staples. Turning the painting upside-down, I double-wet the entire sky area including the spray. But I painted around the large rock. Then I dropped a light wash of raw sienna onto the wet paper, avoiding the spray area. I turned my board back, right-side-up. While everything was still very wet, I added a dark wash of pure cobalt, starting at the top left. As I moved downward and to the right, I dipped less frequently into the cobalt wash, and this permitted more of the raw sienna to show through. When the paint was almost dry, I blotted one or two spots with a paper towel. This evened out some tones, and it was also the beginning of my modeling the spray.

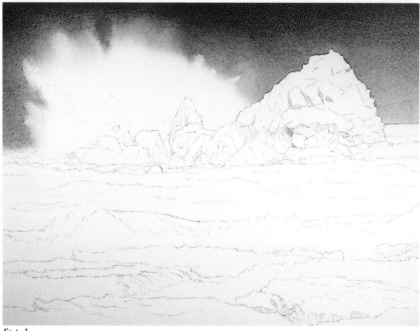

Step 1

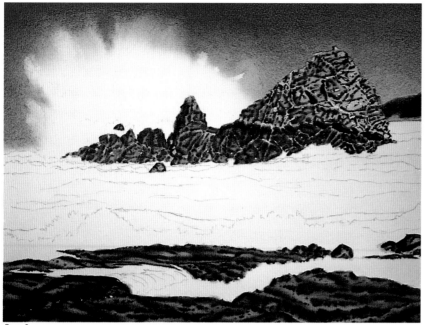

Step 2

Step 2. Notice the subtle gradations achieved by painting into a very wet wash. Even within those gradations, there are softer and harder edges. To begin with, I softened a few edges here and there, mostly where I wanted to keep them similar in value to the background. The base color I used was a mixture of raw sienna, cobalt, and burnt sienna, and my usual two darks. What contributed to the eeriness of this scene was the strange sidelighting, which was caused by the sun projecting through the breaks in the cloud cover, outside the picture area. This was one of the main attractions for me in the first place and became an important part of my painting.

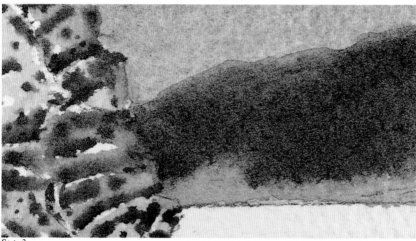

Step 3

Step 3. The background cliffs on the right were painted with olive and cobalt. Because they were painted over previous layers of color, they were already toned down enough to stay put. I created the subtle variations in the background hill by finger blotting, and simply "hit" the darker areas twice.

Step 4

Step 4. My base color was a deep turquoise made of cobalt and olive. Because I started out so dark, I didn't have a lot of room to get much darker. One dark—cobalt and burnt sienna (mixed quite thickly)—would have to do it. I used the same element, the spray stirred up by the wind and tide, in the monotonous stretch of dark middle-ground, just as I had in the foreground. I painted the farthest waves as flat tones of my base color—cobalt and olive. Gradually, I began adding my one dark—cobalt and burnt sienna—to increase the contrast and push the breakers closer. Using my strokes to create an irregular weave of sharp-edged, drybrushed and wet-blended techniques, I worked the edges to reveal the form.

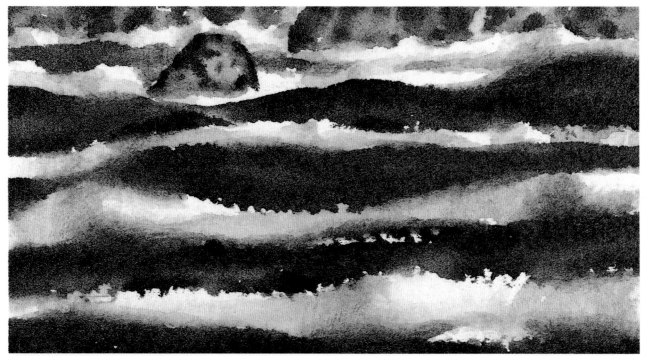

Step 5

Step 6

Step 5. The whitecaps in the background were shaded with the same colors I used in previous steps, a very diluted version of cobalt and olive. While that was still damp, I painted into it with gradually deepening gradations of my darker dark—cobalt and burnt sienna. Remember that shadows on whitecaps appear relatively pale, but in a realistic treatment like this one, they *must* be there. Otherwise, the foam will seem two-dimensional.

Step 6. The whitecaps in the foreground were painted with the same pale colors, but I used considerably more drybrush. This reinforced the impression of a million tiny white bubbles dancing in the foam. The drybrush also helped pull the entire foreground forward by creating the impression of minute detail.

Wet-on-Wet, watercolor, 11" × 15" (27.9 × 38.1 cm).

Finished Painting. Because of all the activity in this painting, I felt that leaving the main foreground burst of water pure white would not be a good idea, so I added more modeling to the great burst of water, which made the splash area appear more three-dimensional, and it holds attention as the center of interest.

Painting Water's Contradictions

16

By dumb luck we had chosen Cumberland Falls State Park in Kentucky as our first night layover on the way to the Great Smoky Mountains. But we never expected the falls to be *this* beautiful. Somehow the humidity in this southern Kentucky area and the mist from the thundering waterfall combined with the late afternoon sun to create a magical light.

As I looked at the falls, the contradictions inherent in the common stuff of water struck me again. Water, heated to boiling for tea, is a gentle steaming beverage. That same steam in a locomotive and tender (224,000 pounds) can propel one hundred and fifteen freight cars and one slightly overweight engineer 3,000 miles across the country.

How can an artist possibly show both the power and the gentleness of falls at the same time? This became the problem for my painting.

Step 1

Step 2

Step 3

Step 1. To begin this watercolor, I redesigned the rocks in the foreground to appear larger. I gave them more pleasing and varied shapes. Finally, I eliminated all the unpleasant intersections. My base color for the background trees was a fairly dark olive and cobalt. My first dark was the standard burnt sienna and cobalt, and my darkest dark was a very dark cobalt and burnt sienna. Since I wanted the trees to have some form, I chose to light them from the left. I made the contrast low to keep the trees in the background and to retain the sensuous, soft lighting of the photo. I kept the values pretty dark so that I had room to play in areas that weren't quite so dark.

Step 2. I premixed five values of cobalt and burnt sienna; the lightest was the bluest, and the darkest was to be the reddest. After double-wetting the water area, I tilted the board a bit and began my lightest (and bluest) wash at the base of the waterfall. As I descended, I kept switching to a darker (and warmer) tone until, at the bottom of the water area, I was using the darkest (and warmest) of the five values. As I painted, I

darkened the right side of the water more than the left to keep the viewer's eye within the picture. I made sure I left occasional horizontal streaks of white paper to suggest foam on the active river. Where the water butted up against the foliage, I finished off the water area with drybrush. If I accidentally covered some of the rocks with my "water" wash, it didn't matter, since the rocks would end up dark anyhow. I painted the falls with a variety of strokes, using the same five-color mixtures but with a lot more contrast, since the falls were my center of interest.

Step 3. I began texturing the water with the third "water" value, using drybrush, wet-blending, and plenty of hard-edged strokes because I was painting the hills and valleys of a very active river! The swells had to be bigger in the foreground and smaller in the background. Since the base color was darker in the foreground, dark texturing would not stand out as much as it would closer to the falls. This kept my center of interest at the falls.

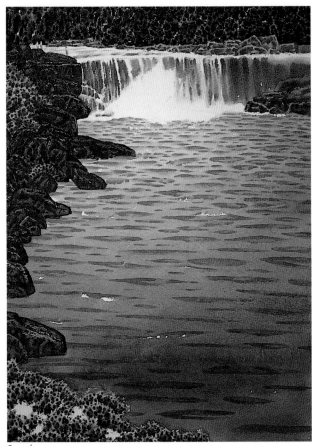

Step 4

Step 5

Step 4. I used one of the darker of my five original "water" grays for the base color of my rocks. Then I shaded it with my two standard darks—first, burnt sienna and cobalt, then cobalt and burnt sienna. I began the rocks at the back, adding water to my base color as I moved forward. Because the shadows remained the same value, this increased the contrast. I also used occasional finger-blotting and lots of scraped highlights while the paint was still damp. The foliage was painted with pure olive and my two darks. Here again, I added water to my base color as I moved forward. I treated the foliage as if it were lighted from the left, just as I had the background trees.

Step 5. The textural effects obtained from scraping and finger-blotting are especially obvious in this closeup. Notice, too, the color changes and the lost edges where the rocks butt against their own reflections. Those lost edges are the means of holding the reflections onto the water surface.

Finished painting. I plugged up the holes in the foreground shrubbery with the background colors. While the paint was still damp, I scraped out the hint of branches with my Aquarelle. I modeled the spray, partially wet-in-wet, by dampening pieces of the spray area and leaving other pieces to dry. I used diluted versions of my two standard darks for this. I did the finishing touches, adjusting my tones as necessary, then worked on those three patient little guys waiting at the edge of the falls. I used tiny dabs of pure cobalt, pure burnt sienna, and a few grays (cobalt and burnt sienna).

By combining effects—drybrush, wet-in-wet—and observing the direction of the light, and by interrupting strokes occasionally to suggest light dancing on the moving water, I tiptoed right past the contradiction I started out with: I've made the water look harsh yet soft, powerful yet gentle. But, most important, I made it look wet!

Moonshine Waters, watercolor, 15" × 11¼" (38.1 × 28.5 cm).

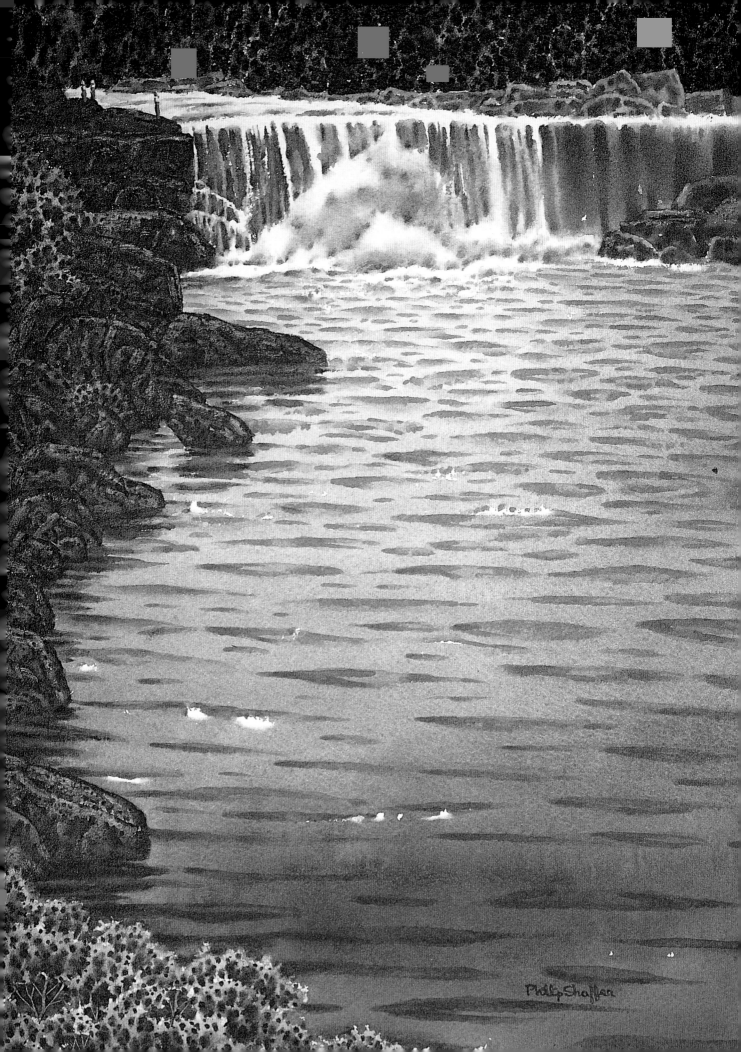

Phillip Shaffer

Re-Creating Textures with Watercolor

17

One year we spent our anniversary in New Orleans. The Dixieland music was great, and the food was even greater. The sense of history there—this cannon and these embattlements from the War of 1812—moved me to paint. I felt especially attracted by the cannon as subject. Somehow, its distortion seemed to symbolize the antiquity of the surrounding area, and the entire 1812 era. The only major change I made was to bring the overhanging tree closer to the cannon, to better tie the two together.

Step 1. I premixed burnt sienna and cobalt, without adding water. Since I liked the white sky in the photo, I kept it that way for the painting. Because I wanted the cool cobalt and the warm burnt sienna of the tree to take turns dominating, I avoided mixing the colors too completely. I dampened the tree area and began painting the foliage with my Aquarelle. For the tree trunk, I used the same colors and a #6 pointed brush. For the smaller branches, I switched to a #4 brush. I applied a bit of scraping with the handle of my Aquarelle, a little finger-blotting, and some edge softening. Notice how I used a variety of textures to create the appearance of age. But I was careful not to use too much so that my background tree didn't seem to move into the foreground.

Step 1

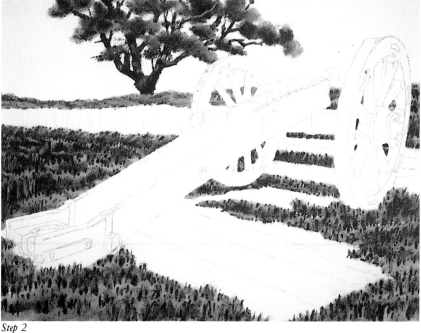

Step 2

Step 2. There's a lot of grass in this painting, but only in a supporting role, so I didn't want to make it too interesting. I used a raw sienna/olive combination—not mixed too well—and an up-and-down "grass" stroke with my Aquarelle. I painted the grass in irregular rows, and while each row was still damp, I began modeling with my two standard darks. The strokes had to be smaller and more subtle in the background than the foreground because of linear and aerial perspective.

To achieve three dimensions in painting grass, think in terms of shading the holes between the clumps of grass because if you tried to paint every blade of grass, somehow it wouldn't look real. For the dead grass along the edge of the vertical log fence, the base color was pure sienna and the usual two darks.

Step 3

Step 3. For my vertical log fence, I mixed a light, cool gray base of cobalt and burnt sienna with lots of water. I used my standard two darks to model the logs, leaving plenty of whites for highlights. Aside from the ol' railroad-track effect of linear perspective, I achieved aerial perspective by permitting my two darks to gradually become lighter and less distinct as the fence receded.

Step 4

Step 4. I used the same colors for the horizontal timbers as I had for the fence, only in lighter tones. Using my two standard darks against the lighter base color gave me additional contrast, which helped project the logs into the foreground. Similar colors tend to tie things together; contrasting values tend to separate them.

Step 5. Initially, I placed a faint wash of pure cobalt over all the wooden parts of the old cannon. Then I began modeling with a middle tone of cobalt and olive to create my aqua color. I mixed the color darker since I planned to remove some of it with finger-blotting, which would give the texture of old rotting wood. I used cobalt and burnt sienna for my darkest dark, along with additional finger-blotting where appropriate. That same darkest dark was used to emphasize some of the texture I created with finger-blotting.

Step 5

Step 6. I underpainted the metal parts of the cannon, except for the barrel, with a fairly dark, warm gray made of cobalt and burnt sienna. Using my standard, bluish, darkest dark, I began modeling the iron tires, the wheel hubs, and the rest of the metal parts. With the same colors, I carefully modeled the barrel of the cannon, preserving my fade-out-to-white because that would cement the painted parts of the picture to the unpainted white paper.

Step 6

Battle of New Orleans, watercolor, 10¾" × 14¾" (27.3 × 37.4 cm).

Finished Painting. In

actuality, I modeled most of the metal
parts of the cannon at the same time as I
painted the wooden parts; they have to
work together. I put down a base wash
for each, then modeled one, then
the other, then back to the first one,
and so on.

From the beginning, I was aware that
I was working with the recipe for a real
disaster. Basically, a cannon is shaped
like an arrow. And an arrow that close to
the edge of the paper points dangerously
out of the picture! A no-no, by any
reckoning. But the severe contrast of the
dark tree against the untouched white of
the paper at left was designed to hold the
attention within the picture.

Controlling Contrasts for Clarity

Long Grove is a charming little town northwest of Chicago. Originally rich farmland, the area had become too expensive to farm, and so it became an easy mark for development. The town is composed of exclusive homes and office buildings nestled among rolling hills, lakes, and carefully manicured acreage. That's why I was surprised when I came upon this dilapidated skeleton of a barn. It presented me with an interesting design problem. I had two trees in front of an old barn that was just a pile of two-by-fours with a roof, set in front of a busy row of bushes. My basic plan was to make a busy picture with barely enough contrast and sharpness to take the painting from the edge of obscurity. Throughout, I had to be careful about what faded off and what remained sharp.

Step 1. I double-wet the sky area, carefully avoiding the outer perimeter of the old barn, then dropped in a bright wash of cobalt with a speck of raw sienna. I also painted around the clouds, making them slant in a direction counter to the angle of the roof. Finally, I blotted out the small cloud at the top center.

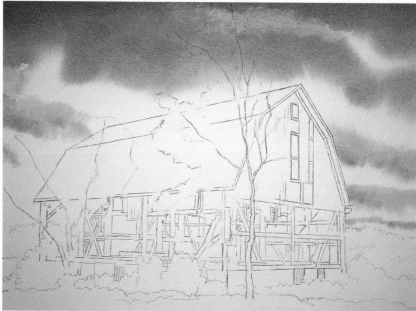

Step 1

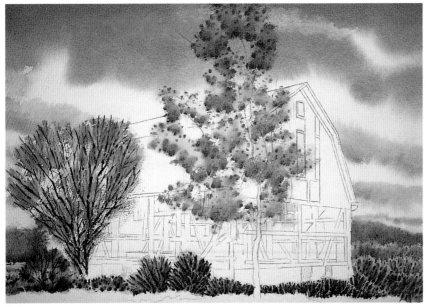

Step 2

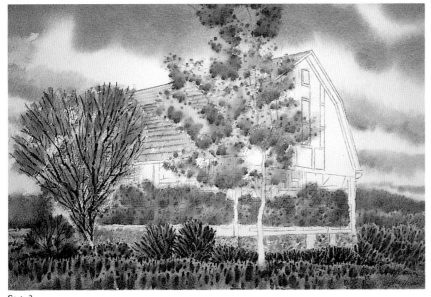

Step 3

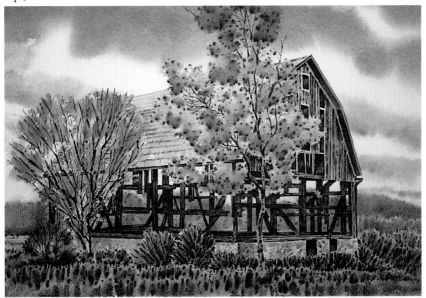

Step 4

Step 2. I premixed the foliage color for the tall center tree, using raw sienna with a spot of olive. My two darks were the usual ones. Since I wanted this tree to end up light against the dark boards of the barn, I didn't let my mixture get too dark. Prewetting the tree area in a kind of hit-or-miss fashion, I dropped in my foliage color. When it was only damp, I modeled it with my two darks. For the remaining shrubbery, I used similar colors but darker and not as bright (more burnt sienna/cobalt and less raw sienna) because I wanted the background to stay where it was.

Step 3. I painted the line of trees—seen through the skeleton of the old barn—with the same colors I had used originally. But I increased the dapple effect by pushing the color and contrast in those areas. The same colors without the green, and greatly diluted, were used in the crumbling cement foundation. To suggest the crusty effect of pitted cement, I used drier paint. I used the same old darks to force the form to turn the corner. Because the roof occupied so large an area and would be a key color in the painting, I worked on it next, using a base color made of olive, a spot of cobalt, and even less burnt sienna. I added only one darker value (equal parts of burnt sienna and cobalt) where the plane changed and to increase the textured look. Next, I painted the grass, using a base color of olive and my usual two darks.

Step 4. The base color for the gray front of the barn was cobalt and burnt sienna, with various dark combinations of burnt sienna and cobalt for the wet-in-wet shading and wood graining. The few boards on the left side of the old barn were a variety of dark mixtures of cobalt and burnt sienna also. In working this area, the only thing that counted was conveying the feeling of a ramshackle barn that had seen better days. Any distortions or exaggerations that helped tell that story were seriously considered.

I defined the tree trunks and branches of the large tree by positioning darks against lights and vice versa. Simplifying some of the tones behind the branches helped also. I softened some of the darks and made others darker. I also softened the contrast as I moved away from my center of interest. To strengthen the color and make the tree come forward, I added more raw sienna in places on the big tree.

Finished Painting. I had set the painting aside for six months in order to see it with fresh eyes. At last I was ready for the fine tuning. First, I lopped off about a half inch from the top of the painting. Then, using opaque gouache (opaque watercolor), I mixed raw sienna with a little zinc white. I prewet small sections of the painting. Using wet-in-wet, I repainted portions of the big tree that weren't bright enough. I'm especially cautious about this because too much opaque is worse than none at all. I further refined soft edges/hard edges, bright colors/grayed colors, and solid forms/ambiguous forms. I considered the painting finished . . . but maybe you better check back in six months!

LONG GROVE GOTHIC, *watercolor, 10½" × 15" (26.6 × 38.1 cm).*

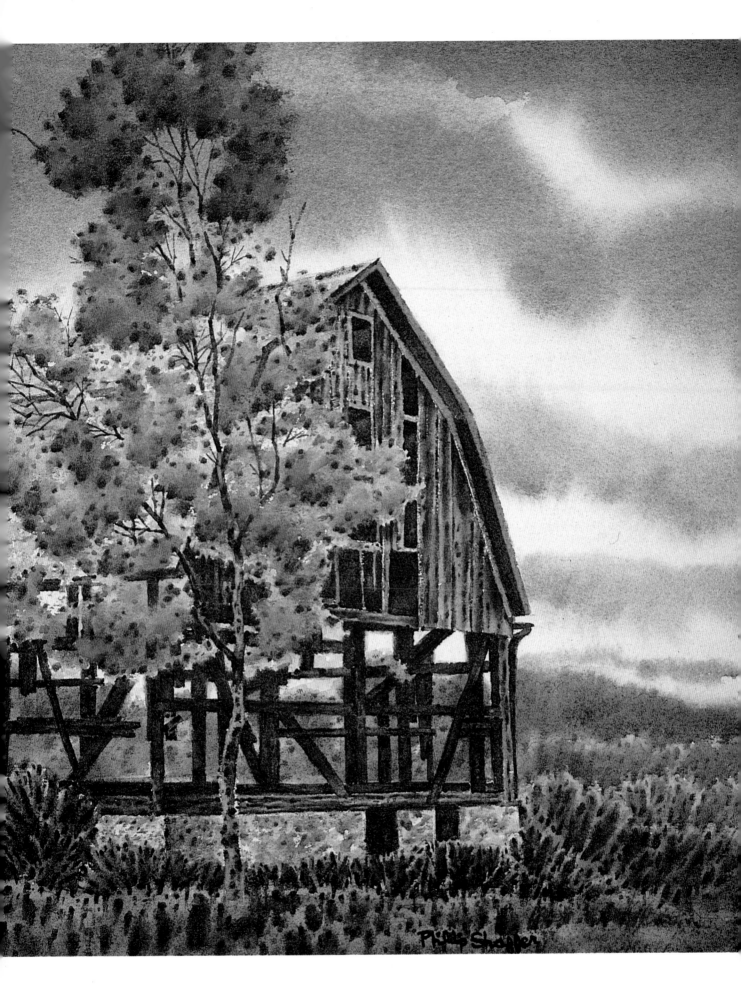

Planning "Happy Accidents"

19 The small town of Chalmette, near the Louisiana coast, was the scene of the last skirmish in the War of 1812. The battle had been won by a brilliant, outnumbered American army two weeks *after* peace had been signed. With its ever-present live oak, this old mansion, the home of the original plantation owner, symbolizes the ongoing paradox of this beautiful area.

In the pencil drawing, I defined the main branches and only hinted at the rest of the old tree; I wanted the "happy accidents" of my brush to create the actual foliage. The building was simplified and drawn quite carefully, but notice how the perspective in the photo appeared incorrect.

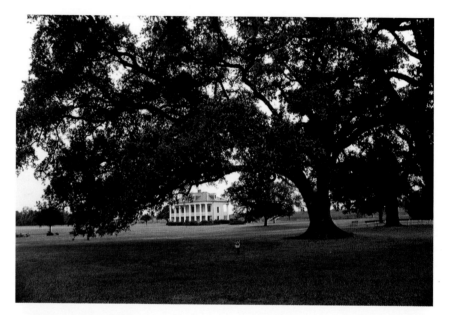

Step 1. To begin, I premixed a midvalue of pure cobalt in one slot of my mixing tray and pure raw sienna in another. Double-wetting the sky, I carefully wet around the old mansion. Then I tilted my board, and starting at the top, I applied the blue wash. As I descended, I began adding a raw sienna wash until the wash was almost pure raw sienna at the bottom of the sky area.

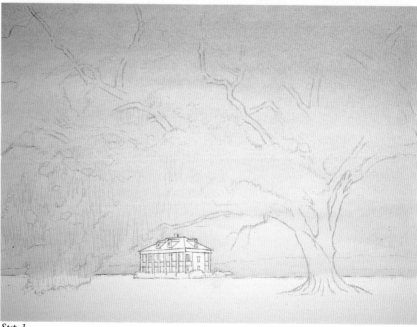

Step 1

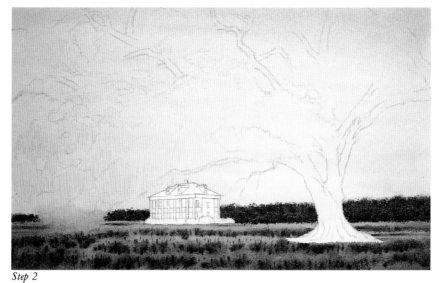

Step 2

Step 2. I used a base color of pure olive for the entire background grass area. Starting at the back, I placed vertical irregular strokes into the wet paint, using my lighter dark—burnt sienna and cobalt—then switching to a new darker dark—olive, lots of cobalt, and burnt sienna. When everything was dry, I mixed olive, cobalt and burnt sienna, and *pushed* my Aquarelle brush to create the hedge. With a damp brush, I softened some of the foliage. In order to simplify the background, I combined the background grassy area, the hedge, and the ridge. I changed the direction of the sun so that the light, spindly areas of the building would pop out against the deeper shadow area.

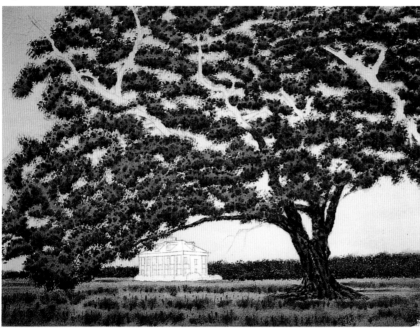

Step 3

Step 3. The base color for the tree's foliage was a mixture of olive, burnt sienna, and a tad of cobalt. My first dark was burnt sienna with just a little cobalt. My second dark was olive, lots of cobalt, and just a little burnt sienna. I designed the foliage as I painted it: graceful shapes, variations in paint strokes and edges, and wet-in-wet variations in color so that the foliage would have its own color, different from that of the trees. For the tree trunks and branches, I used a burnt sienna and cobalt base color and one of the darks I had used for the foliage. I used only one dark (olive, cobalt, and burnt sienna) because the base color was already so dark. I stopped mid-tree so that you could see how, beginning at the base and working upward, the limbs were built up.

Step 4

Step 4. The roof was painted with cobalt and a squish of burnt sienna; this was used in the shadow area also. The base color of the old building itself (sans post and trim) was a soft pink made of heavily diluted, pure burnt sienna. Then I added diluted versions of each of my shadow colors for modeling. I avoided making edges too neat and I deliberately overlapped some edges. I glazed one tone over another, permitting it to "puddle" if it chose. To this point, much of this painting had been drybrush; this wet-painting provided the right watery touch that shouted "Watercolor!"

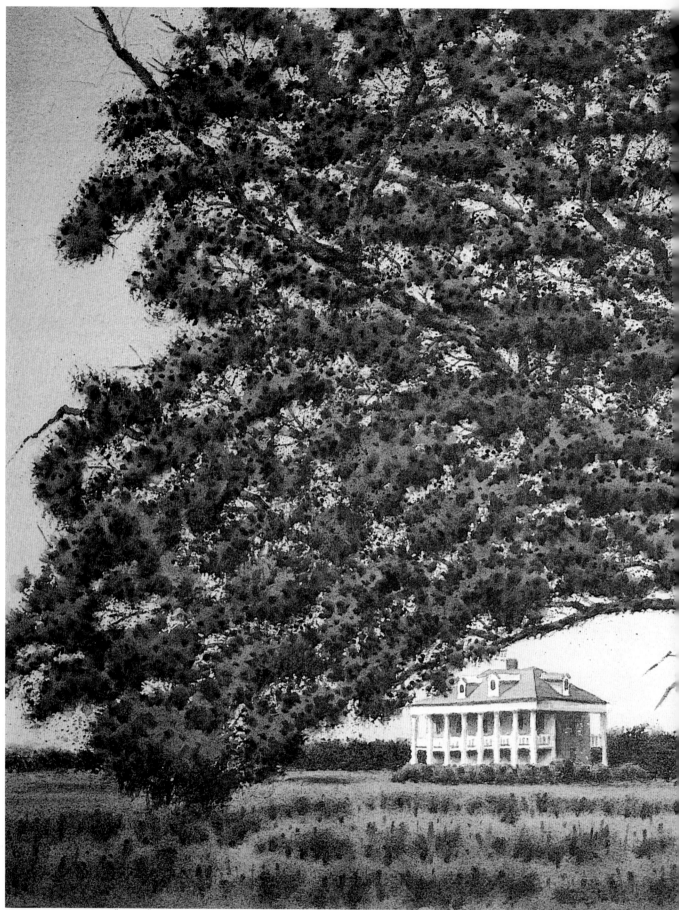

DIXIELAND, *watercolor, 11″ × 15″ (27.9 × 38.1 cm).*

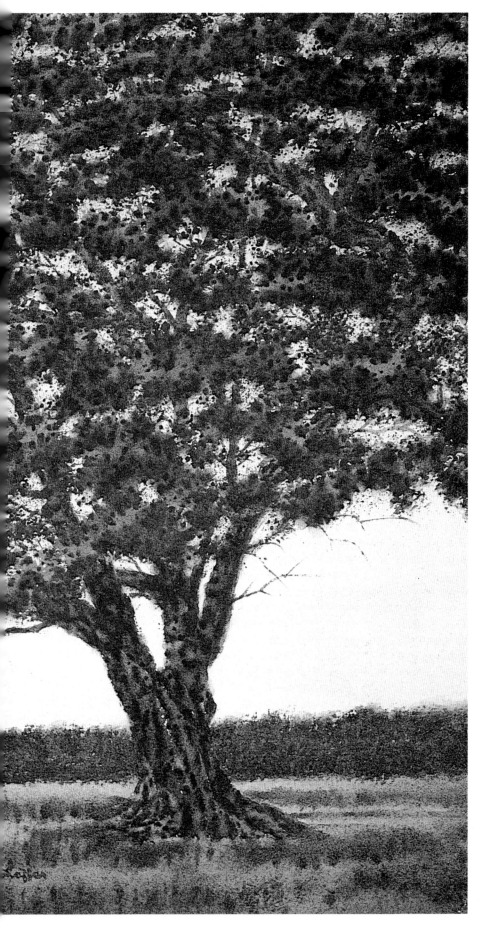

Finished Painting. As simple as this painting is, I spent a lot of time pulling it together. I redesigned the sky holes with irregular brushwork, drybrush, wet-in-wet, and spatter to close the gaps between clumps of foliage and unify the tree. I used a little opaque watercolor to correct the perspective on the old building. I positioned the tree trunk lower to anchor it and made sure the tree remained as a framing device for my real center of interest, the old mansion.

Emphasizing Textures

20

One of my favorite Chicago buildings was the Diana Court Building. This structure, which housed the offices of Time/Life Inc., was built around a beautiful interior courtyard that at various times served as a restaurant, an indoor shopping plaza, and a glamorous bar. With its fountains and its statue of Diana, it was a favorite meeting place for all Chicagoland. Then someone decided that more money was to be made from a newer building, so as each tenant's lease was up, it was not renewed. Eventually, the dignified old building was empty—except for Dunhill Tobacco Company, which still had time left on its lease.

The building's owners offered Dunhill all kinds of inducements, but Dunhill wouldn't budge. Finally, the owners tried a different tack—they began demolition! For years Dunhill conducted business as usual, while the Diana Court Building was being reduced to the two floors that Dunhill occupied. Then, when Dunhill's lease was up—long after the demolition team had given up and gone home—Dunhill quietly moved out. I'm a sucker for David and Goliath stories like this!

Pencil Drawing

Step 1

Step 1. I began with an elaborate pencil drawing because of the many planes and angles. I had to shift some of the buildings to avoid confusing tangents. To protect all the light-colored windows and the door in the background, I used strips of tape. After premixing each of my colors, I began at left on the first building with a dark mixture of raw sienna and cobalt. For the second building, I applied thick cobalt and burnt sienna. The building showing up as a small triangle at the very top of the paper is burnt sienna, cobalt, and raw sienna. The building at right is olive, cobalt, and a little burnt sienna in two different values. I mixed a light wash of pure sienna to use as my underpainting. After double-wetting the unmasked areas, I applied the underpainting and, starting at left, began painting the buildings. For the greenish building at right, I painted the lighter tone and the diagonal shadow first. While the paint was still wet, I put in the vertical lines of the windows with my darker green mixture, encouraging the lines to blur. Varying the tones within each building created eerie, interesting shadows.

Step 2

Step 2. When I removed the tape, I realized that the edges needed to be softened. Left white and hard edged, the windows seemed to leap forward. I used a well-worn bristle brush to soften them.

Step 3. The reason I gave all the background buildings a preliminary wash of raw sienna became apparent at this point. I merely had to add detailing to the closest background building. Starting with light values of burnt sienna and cobalt, I also used a darker mixture of cobalt and burnt sienna—applied wet-in-wet to model the window and wall details. I redesigned the hole in the glass to simplify it, create a better abstract shape, and make it look more like glass.

Step 4. I mixed a soft, dusty-glass color, using a light value of olive, burnt sienna, and cobalt. I painted each pane separately, wet-in-wet, adding whatever color happened to be behind the glass. I permitted the buildings seen through the glass to blur more than those seen directly. Because the hole in the glass is my main center of interest (within my general center of interest, the blue door), I needed a great deal of contrast for it. So, around the broken glass, I used either the original white paper or scratched back to white with my X-Acto knife. To pop the dark hole of the broken window, I thickened my colors clear to black.

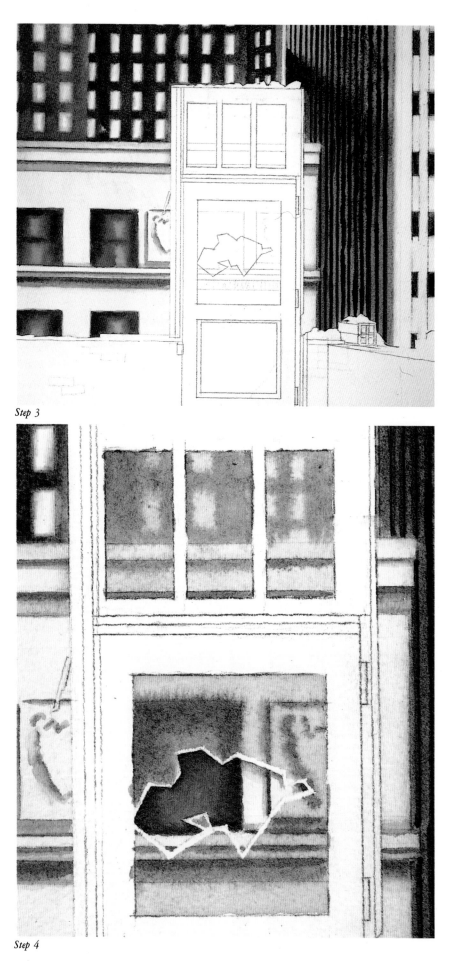

Step 3

Step 4

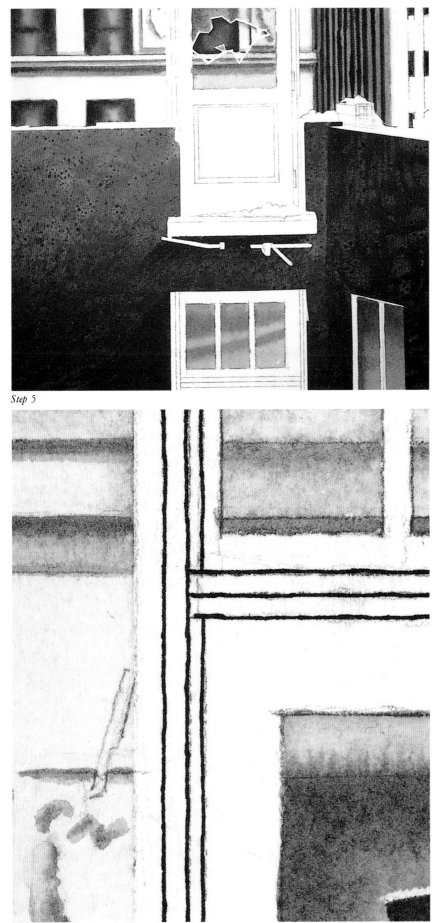

Step 5

Step 6

Step 5. I painted the glass in the window and door at the bottom right, using the same base color as before (olive, burnt sienna, and cobalt) and added cobalt to darken it. Then I added my two standard darks. With masking tape, I masked off everything except the foreground building. Then I double-wet the paper and applied lots of a fairly thick mixture of pure raw sienna. Next, I began blending pure burnt sienna into it, leaving only a narrow strip of raw sienna down the middle. While everything was still wet, from the bottom up I began darkening with cobalt. I also used cobalt to darken the wall on the right and the diagonal cast shadow. With a bristle brush, I spattered a dark burnt sienna/cobalt mixture over the still-wet brick area.

Step 6. To avoid losing pencil detail against the dark door, I retraced my lines with a ruling pen and black waterproof ink. I used a ruling pen because it's the easiest to clean, the quickest way to switch colors, and the least expensive way to change line weight—simply turn the thumbscrew. But it takes some getting used to . You have to hold the pen perfectly vertical. After placing a drop of ink or watercolor between the blades, run your finger along the outside to get rid of any ink that might come in contact with your straightedge. Use something to raise the straightedge off the paper so that the ink won't get underneath. I use three layers of masking tape, placed an eighth of an inch back from the edge of a triangle. Don't fill the pen too high, and clean it after each use. If you want your line to imitate the warped wood in an old beat-up door, just wiggle the pen back and forth a bit as you draw your line.

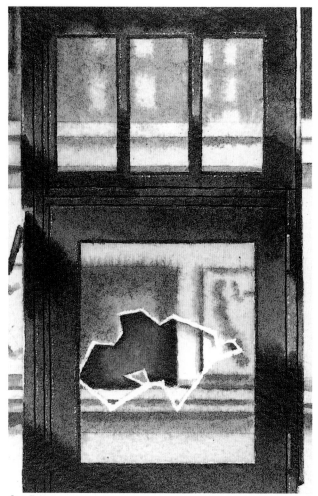

Step 7

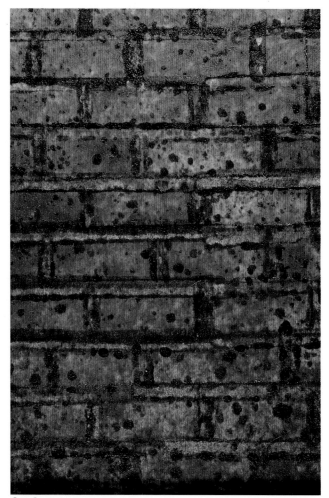

Step 8

Step 7. I used a medium value of cobalt and burnt sienna for lighter parts of the door, and I mixed a very dark cobalt, olive, and burnt sienna for the darks. To create additional interest, I dreamed up a raking, diagonal light. I finished off all the odds and ends, using raw sienna as a base color, and my standard two darks. Although the pure white in those background windows adds sparkle, it pulls the windows forward. To make them recede, I applied a light green tint (olive and cobalt) to them. To suggest years of chipping and repainting, I brought out highlights with the X-Acto blade.

Step 8. To stamp the mortar between the bricks, I used a thin strip of mat board and my dark—cobalt and burnt sienna mixture. The paint-moistened cardboard added pigment in some places and actually removed pigment in others. My brick texture turned out very convincing.

Finished Painting. Since the lightest building still looked like a negative area, I used sponge-stamping, spatter, and scrubbing-out to suggest a rough cement texture. I masked off the background again and floated a light wash of pure raw sienna over the building. I darkened the background windows once more and further adjusted some of the other tones. Using diluted zinc white (opaque watercolor) and a speck of raw sienna, I did a bit of retouching. Pure white, applied translucently over a darker color, is always cold (bluish). If you want white to appear neutral, you need to add a warm touch, like raw sienna. But if you're painting over a color that's already warm, you'll need to add something stronger than raw sienna—like cadmium orange. I separated the immediate foreground even more by darkening the tone right behind it. Then I modeled the foreground rubble a bit, sharpening here and softening there. And so I made today's progress on *Yesterday's Progress!*

YESTERDAY'S PROGRESS, watercolor, 14¾" × 10¾" (37.4 × 27.3 cm).

Maintaining Atmospheric Gradations

21 Our vacation in Great Smoky Mountain National Park began poorly: "I'm sorry, Mr. Shaffer, but we don't have any record of those reservations." Then the woman's face brightened as she remembered: "The manager is going to be away for a few weeks and you can have his cozy little apartment." The five of us hoped it wouldn't be too cozy.

It turned out to be a split-level luxury apartment that slept ten, and because of the reservation mix-up, they charged almost nothing. Perhaps it was the contrast between the dismal beginning and the final outcome that determined that flowers would become my symbol for this park.

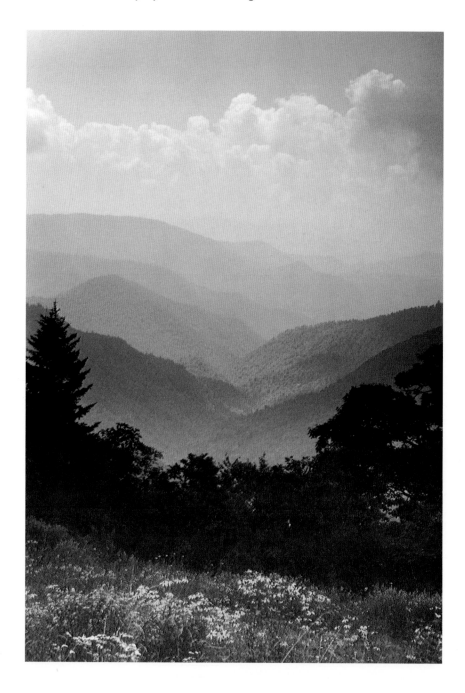

Step 1

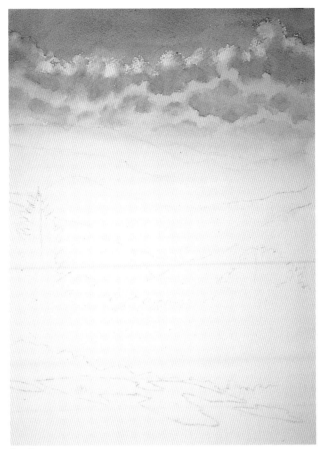

Step 2

Step 1. Because the smoky atmospheric gradations in the faraway mountains were so subtle, I indicated the mountains very lightly in my pencil sketch. The abstract shapes in the foreground in the pencil sketch were a rough guide for the flower beds. The indication of the single flower reminded me of the scale. Since I planned to mask off every flower anyway, there was no point penciling each one. You'll notice that I moved them much closer than in the photo, creating a stronger center-of-interest.

As usual, I premixed my colors—cobalt and raw sienna—slightly darker than in the photo; these were to be used for the sky. I painted with a one-inch Aquarelle to create drybrush edges. For variety, I wanted some softer, wetter edges, and blended off with a drybrush clumps that didn't succeed. When everything was dry, I used a stiff bristle brush to soften additional edges.

To achieve a glow in my underpainting, I mixed raw sienna and cobalt. With a one-inch flat watercolor brush (not the Aquarelle), I painted the lighter tone of the clouds, using a pushing stroke along the top edge for a drybrush effect, then softened some of those edges with water. I also blended off the bottom edge of the clouds with clear water.

Step 2. Using a slightly darker value of cobalt and raw sienna, I began modeling the clouds, pushing the contrast as the clouds became closer. Drybrush, wet-brush, and every-kind-of-brush was used to create interesting strokes.

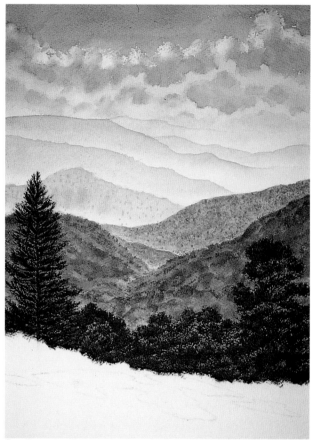

Step 3

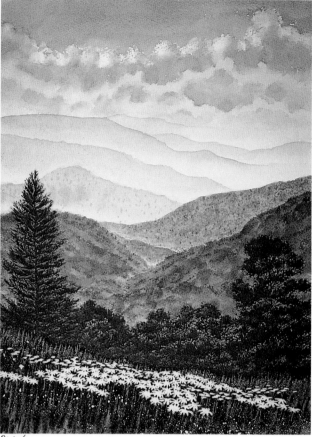

Step 4

Step 3. Since the background mountains set the stage for the atmosphere of the entire painting, I was extremely careful about their value, color, and texture. I premixed various combinations of cobalt, olive, and burnt sienna, making sure that the farther back the mountains were, the closer to "sky color" they became. The mountains fading in and out of the sky created the special lost-and-found atmosphere that attracted me to this scene in the first place. Finally, I added the foreground tree and shrubbery with a pushed half-inch Aquarelle and two dark, close values of cobalt, olive, and burnt sienna. I used a small, round brush to add the twigs that lent authenticity to the effect.

Step 4. Using the abstract shapes and the single flower that I penciled in to begin with, I also penciled in numerous ellipses to represent the perimeters of the petals of the other flowers. These ellipses became smaller and flatter as the flowers receded into the background. Just before painting, I masked each and every petal with Miskit and a small brush, trying to do each petal with a single stroke. I kept in mind how each flower radiated from the center in perspective. I also made sure that there were plenty of overlaps and irregularities so that the flowers looked natural. Finally, I spattered the flower area with a stiff bristle-brush and additional Miskit to represent the small weeds and flowers that grew beside the larger plants. This created an important transition. I premixed the dark, grassy foreground immediately behind the flowers, using pure olive as the base color and my usual two darks. Then, double-wetting the area, I painted in vertical grass strokes. When everything was dry, I removed the Miskit.

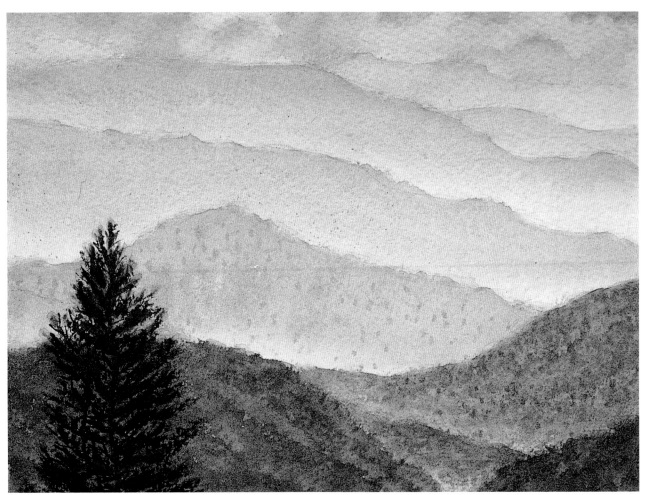

Step 5

Step 5. When I painted the crisp edges and textures of the background mountains, I was aware that they would have to be adjusted. But without other edges and areas to refer to, I had no idea how little or how much, so I put it off till this step. I softened lots of edges, losing some completely, especially in the far background. With finger-blotting and light washes, I controlled the textures, making them heavier in the foreground and softer in the background. I even retouched the background a bit to make them smoother. This made the washes in the foreground appear rougher.

Step 6. To soften the edges of some of the flower petals, I used a small, stiff nylon-bristled brush, originally intended for acrylics. This eliminated much of the "pasted-down" look, even though the contrast was still extreme.

Step 7. I painted the large flowers with pure new gamboge, and I placed a burnt sienna/cobalt center in each flower. A light mix of raw sienna, burnt sienna, and cobalt added shadows and, consequently, three dimensions, For the smaller, round flowers, I simply used a light wash of pure cobalt.

Finished Painting. After toning down some of the light blue flowers that appeared too strident, I also softened some of their edges. Then I added a light burnt-sienna/cobalt center to some of them. I also softened some of the yellow flowers and the spattered weeds. A little more finger-blotting on my dark, middle-ground foliage, and there it is—another masterpiece!

Step 6

Step 7

SMOKE AND FLOWERS, watercolors, 15" × 11¼" (38.1 × 28.5 cm).

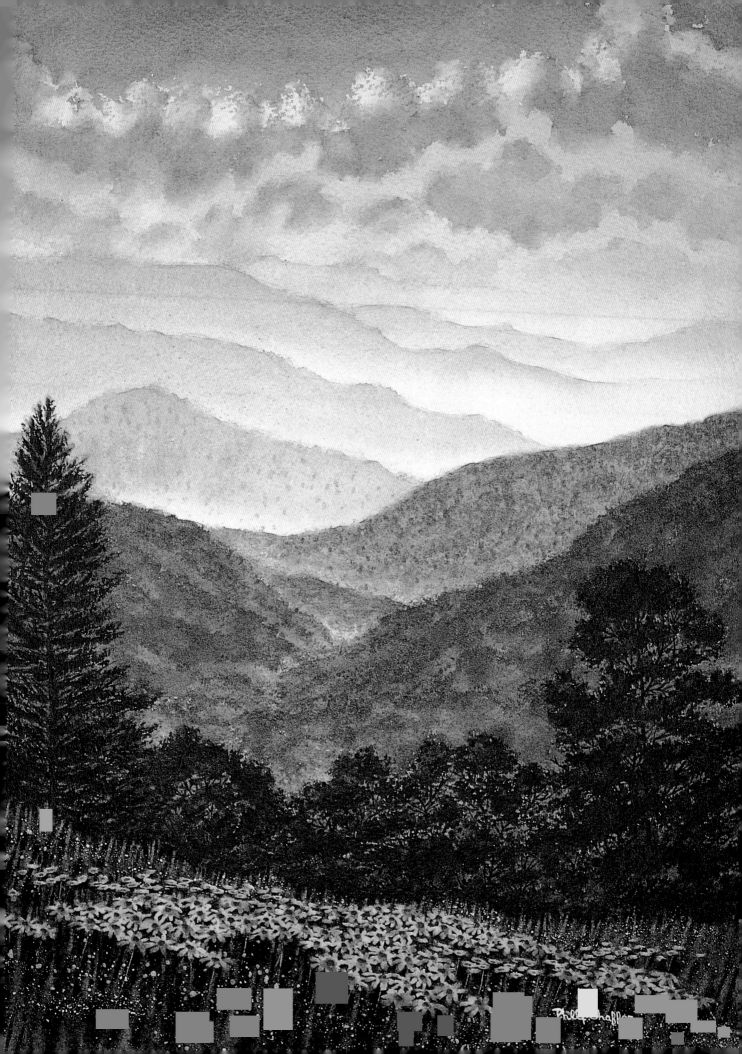

The Unique Problem of Painting Snow

22 I choose to live in Jackson, Wyoming, because I think Grand Teton National Park, our neighbor, is the most beautiful spot in the country. When we first moved to Wyoming, I had never skied. But you can't just *walk* on sixty inches of snow. If I wanted to enjoy my subject in winter as well as summer, I certainly had to learn to ski. Cottonwood Creek in Grand Teton National Park is as far as cars can go in the winter. (They have a great way of closing the road—they just don't plow it!) From there on, it's cross-country skiing, snowmobile (noisy, smelly, and frightening to the wildlife), or couch potatoes. Although it's easier to ski on preset tracks (ski paths someone else has made), there's a certain pride of ownership when you realize that your tracks are the only ones around.

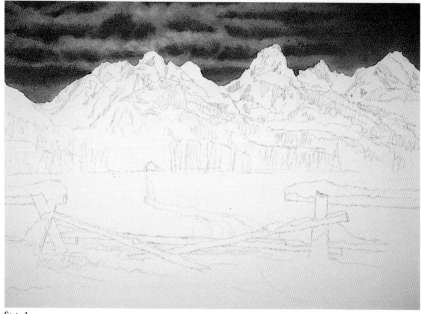

Step 1. This painting practically composed itself. All I had to do was shift a few things here and there, change a couple of size relationships, and intensify some color. As usual, I premixed my base color for the sky—raw sienna and cobalt, with a dab of burnt sienna. Then I mixed a single, rather thick dark of cobalt, raw sienna, and a tad of burnt sienna. Turning the painting upside-down, I double-wet the entire sky area. Then I turned the painting right-side-up again and evenly distributed my base color over the wet paper. This would eventually be the light area of the clouds. I used my single darker tone to begin modeling the patchy sky. Each brushload was begun in an area where I wanted the tone to be relatively dark. Then, as the paint on my brush became more diluted from the wet paper, I painted lighter tones. Finally, when the paper was just damp, not wet, I made one more pass with a fresh load of dark tone, accenting the edge of a cloud here and there to provide additional form and variety.

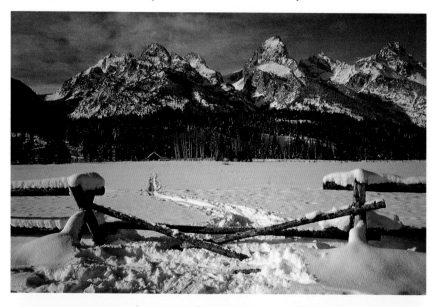

Step 1

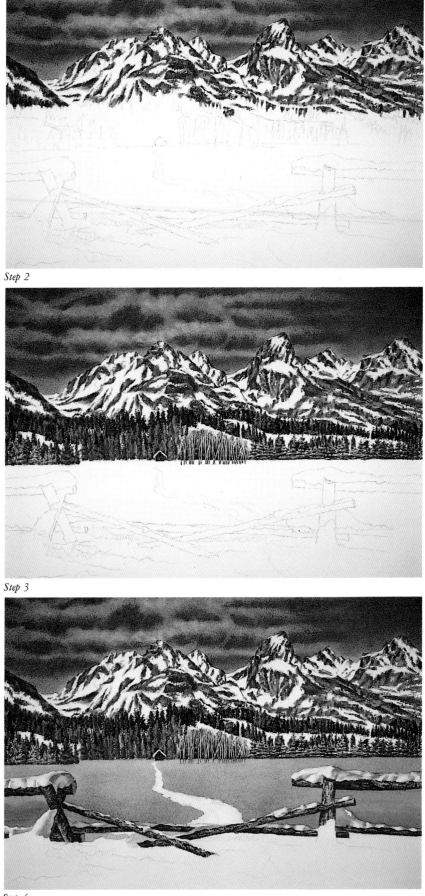

Step 2

Step 3

Step 4

Step 2. Because I planned to apply the paint almost drybrush, I premixed my base color for the mountain darker than I wanted it to appear. That way the occasional drybrush "skip" would leave the impression of a snow-covered mountain. The first dark was burnt sienna and cobalt; the darker dark was cobalt and burnt sienna. Aside from being the perfect combination for modeling, these two colors enabled me to bounce color into the shadows and still retain control over my warms and cools. By adding more burnt sienna, I'm able to control how warm the magic mix becomes, and by adding cobalt, I can control its coolness.

Step 3. The base color I used for the far middle-ground evergreens was olive, burnt sienna, and cobalt. I painted the trees individually or in twos and threes, using the same two darks discussed in Step 2. Sometimes I used the warm shadow alone, sometimes the cool shadow, and sometimes both. The bare aspens in the center were achieved by carefully painting around them. When they were completely dry, I washed a light tone of raw sienna (with a speck of burnt sienna and even less cobalt) over them. A fairly dry brush was used to avoid disturbing the surrounding color. Then I added my two darks to delineate and separate the individual trees. Finally, I painted the old log cabin almost pure burnt sienna, with just a trace of cobalt to darken the color.

Step 4. I used a damp brush to soften the bottom edges of the middle-ground trees. Then, with Miskit and lots of soap, I masked off the leading edge of the buckrail fence and the ski tracks. To bring out the white of the paper, my snow, I mixed a medium-light value of cobalt and raw sienna wash for my first middle tone. Then I made a fairly dark value of the same two colors—heavier on the cobalt—for the darker middle tone. I tilted the board, wet the snow area, and used my lighter tone, darkening the wash as I worked down the page. When everything was dry, I removed the Miskit and painted a light wash of raw sienna and a little cobalt over the foreground logs. While that was still damp, I used a hot, dark mixture of burnt sienna and cobalt for my first dark, and a darker mixture of cobalt and burnt sienna for my darker dark. I applied the paint thick with quick drybrush strokes to create a weathered texture.

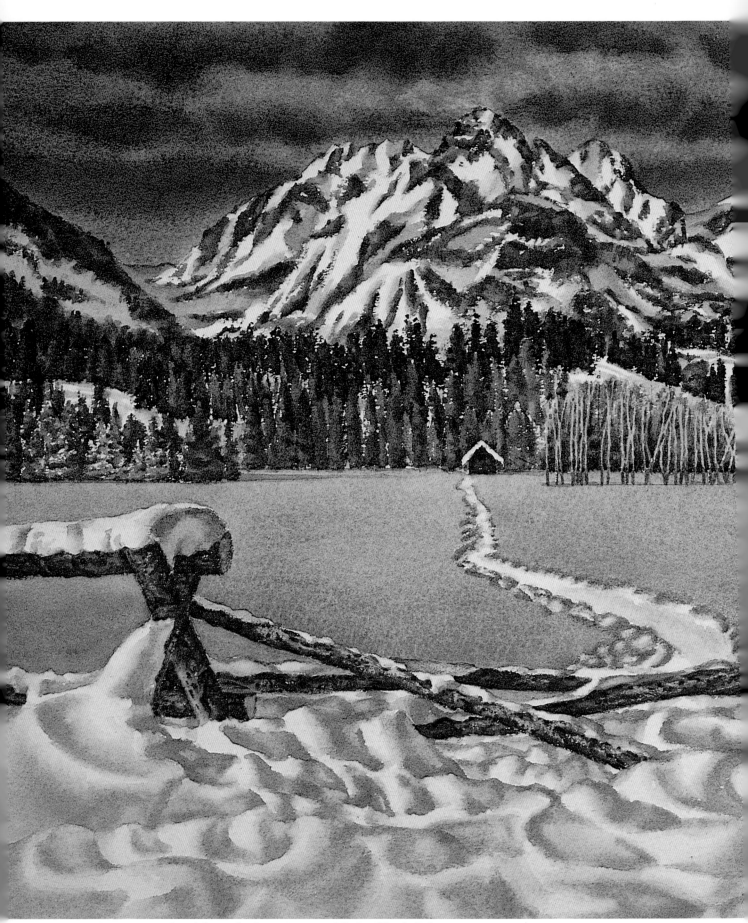

FIRST TRACKS, watercolor, 10¼" × 15" (26.0 × 38.1 cm). Collection of Timothy Forbes.

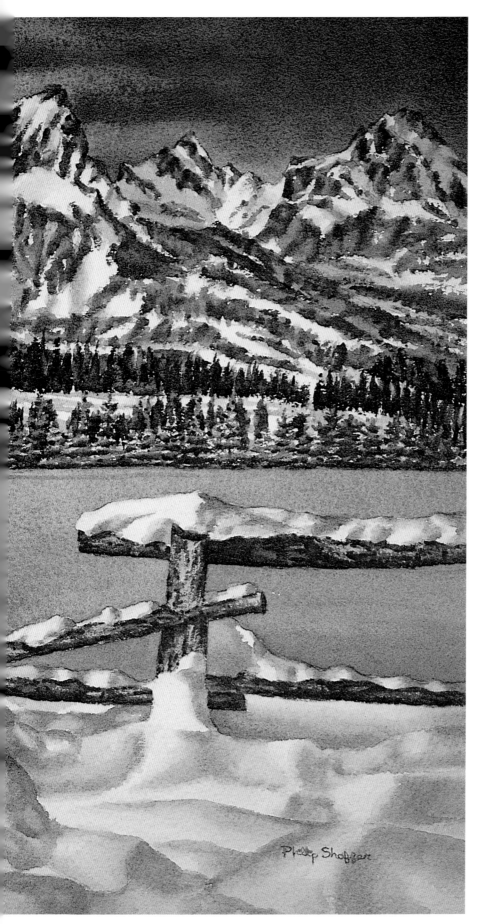

Finished Painting. I softened some of the edges of the snow on the fence and began modeling the fence with the raw sienna-and-cobalt first dark and the cobalt-and-raw sienna second dark I had used before. Using the same color mixtures for the immediate foreground, I painted the clumps in the snow, making sure that I provided plenty of variation in size and shape and made the clumps appear larger as they came forward. Finally, I painted in the ski tracks, providing them with sufficient contrast to lead the eye back to the tiny cabin—and hot cocoa at last!

CORRECTING PAINTINGS

All artists have paintings that they wouldn't show to their pet chinchilla but that aren't bad enough to dump. These paintings can be the beginning of creativity at its most fun. Since there's nothing as satisfying as completing and framing a watercolor you considered a total loss, I am confident that you can increase the quality and productivity of your art by converting your former losers into gold-medal winners.

The first order of business is to divide your fiascos into three stacks. In the first stack, you can put those paintings that can be fixed most easily. For these, you'll be using the watercolor medium itself to solve the problem. I use scrubbing out, repainting, and an old technique, brought up to date by Andrew Wyeth, called watercolor drybrush. It's done by dipping a small brush into paint and

drying it first on a blotter, then between your fingers. Then you stroke the brush over the paper surface to create a combination drybrush/wet-blended edge that melts right into the tones of the painting.

In the second stack, put those paintings that would require so many changes that it would be easier to trace your pencil drawing onto a fresh sheet of paper and start all over again. Or you can use the watercolor as an underpainting and place an opaque medium right over it. If you use it thinly in minute, isolated areas, opaque paint—designer's colors (opaque watercolor, or gouache), acrylic, casein, or pastel—is practically invisible. But if extensive opaque is required, it's best if most or all of the surface is covered with the new medium.

Sometimes the problems can't be solved at all. Correcting one element

simply makes another incorrect, or if you do more scrubbing, you'll just go through the paper *and* the drawing board. I put these paintings into the third stack—and I *eliminate* the problem by getting rid of the paintings! It hurts, but even then it's not a total loss. If the backs of the paintings are clean, I've got a free second chance. If not, then I tear the paper into small pieces, which I use for trying out my colors. Either way, I experience a wonderful sense of peace and relief at not having to worry about *that* one anymore.

The examples I'm showing you here are only a few of the ways to rescue a painting. As you accumulate more good paintings, you'll also end up with more "bad" paintings, and your desperation will prompt you to invent "rescues" that no one has dreamed up yet. And that's creativity.

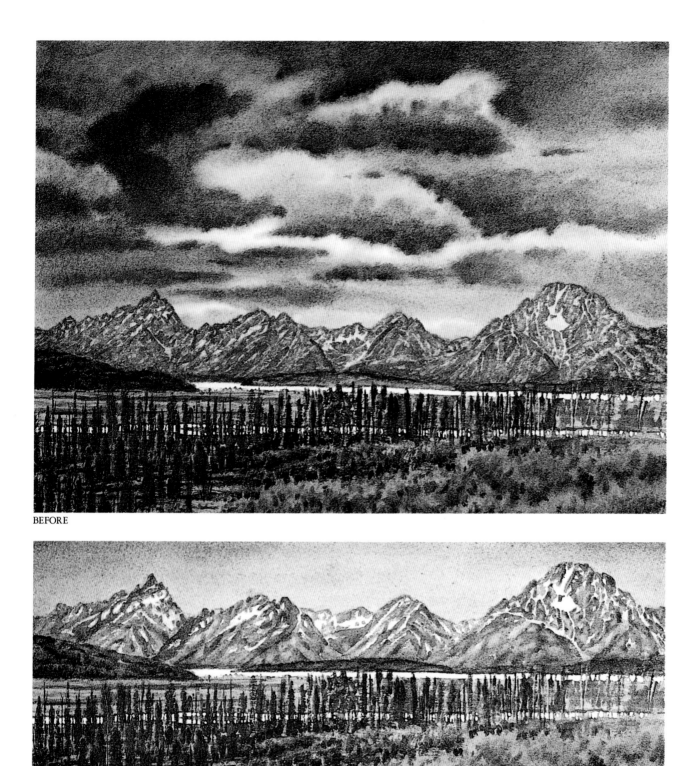

BEFORE

AFTER

SUMMER RAIN, *watercolor, 6" × 14½" (15.2 × 36.8 cm). Collection of Robert and Elizabeth Howell.*

In the original version of Summer Rain, *the beautiful texture of the foreground foliage was totally lost because the sky was* too *impressive! Masking off the bottom of the painting with masking tape (beginning at the top edge of the white strip of water), I removed all the color with a soft sponge. Then, using a second strip of tape to remind me where the new sky should crop, I wet the sky area with clean water and painted back in a simple cobalt-to-raw-sienna sky. Finally, the mountains were reinstated—simpler and with more contrast.*

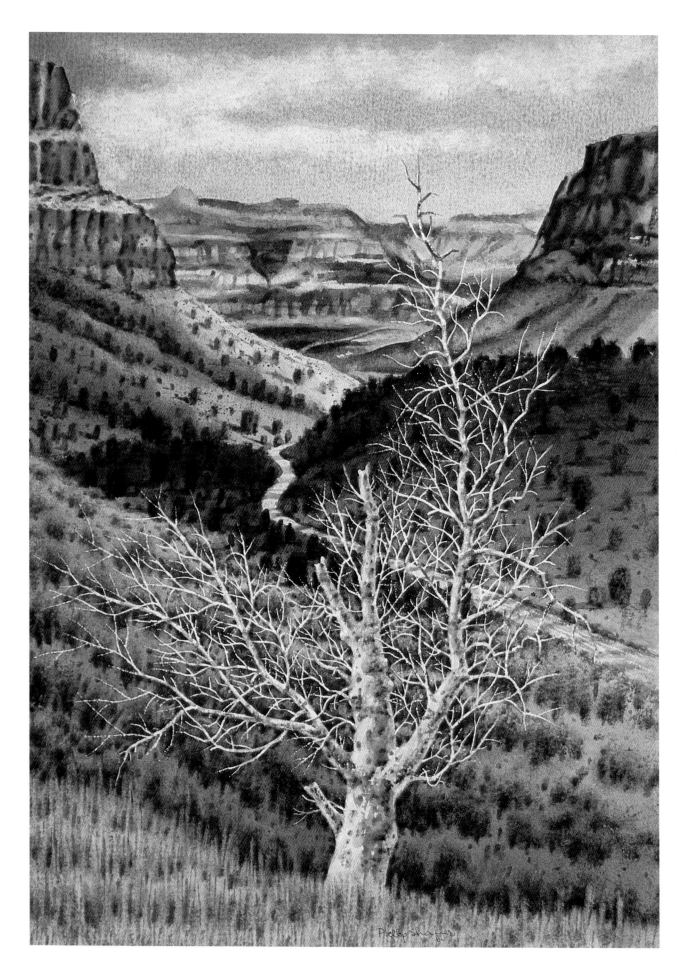

QUAKERS, watercolor, 10½" × 14" (26.6 × 36.8 cm).
Collection of Mr. and Mrs. Winton Winslow.

The background trees seemed to work out okay, but the foreground foliage was somehow boring. To remedy this, I darkened the area, and when it was dry, I cut a leaf-shaped template out of acetate. Using the template over and over with a damp sponge, I lightened each individual leaf. Then, when everything was dry, I painted color and detail back in. (Notice how spatter eased the transition in the background.)

PLATEAU POINT TRAIL, watercolor, 14½" × 10½" (36.8 × 26.6 cm).
Collection of Mr. and Mrs. Robert Heiser.

Plateau Point Trail *did not really have any major changes, but it sure had a whole mess of small ones. I began painting by masking off the tree and painting the background. When I removed the liquid mask, I discovered that many of the narrower branches were no longer narrow—because of my difficulty in seeing even the bright orange masking. I had to use watercolor drybrush to retouch the background in order to make the branches narrow again. Also, to project the tree forward, there had to be adequate contrast. However, the tree—including the spindly, narrow branches—had to remain light; otherwise, against the dark background, it would disappear.*

MORNING RIVER,
watercolor and watercolor
over acrylic, 10¾" × 14½" (27.3 × 36.8 cm).
Collection of Richard and Sharon Adomitis.

Morning River *is here under false pretenses.
There are no major corrections made here at all,
but I wanted to show how, with a little
preplanning, some of the problems shown in the
remainder of the chapter could have been avoided.
I prepainted the foreground shadow area (up to
midmountain) with a light/medium wash of pure*
acrylic *cobalt blue. Since acrylic is waterproof, it
provides a cool beginning shadow that won't muddy
subsequent layers.*

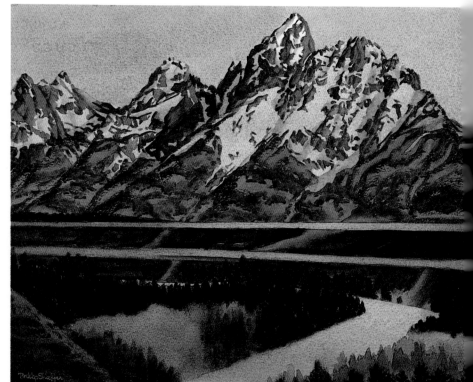

TEA WITH THE MORANS,
casein over watercolor,
10½" × 15" (26.6 × 38.1 cm).
Collection of the artist.

As Tea with the Morans *neared completion, I
realized that the values were wildly out of control.
At that point, I could either start over again or
just continue—using an opaque medium. Since I
liked my concept, I chose to complete the painting
working with casein. Casein is an especially
opaque medium—one of the most permanent
around. I love its crusty, dry texture. I hope that
Thomas Moran, the famous landscape painter after
whom this painting and the mountain in this
painting were named, would approve of the work.*

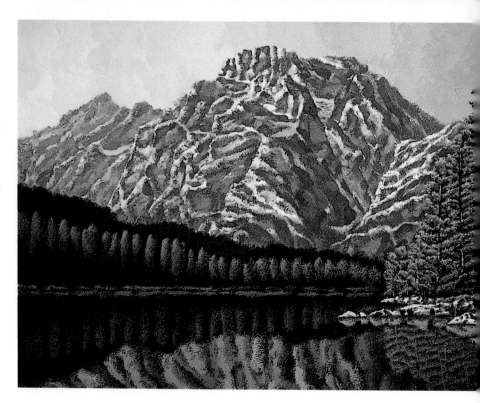

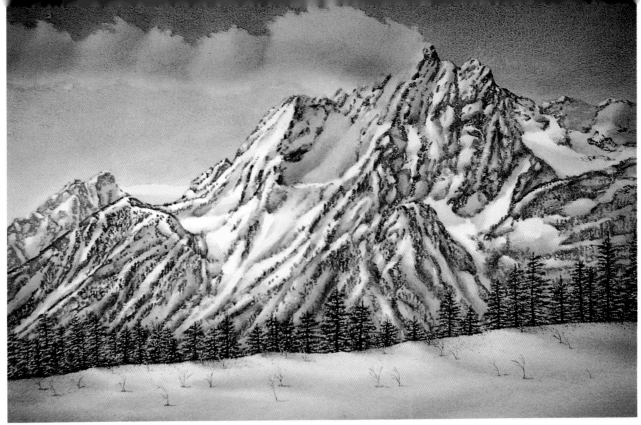

BEFORE

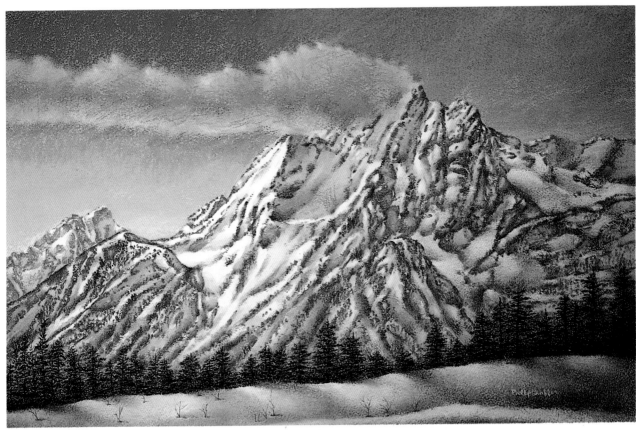

AFTER

WARM WINTER WIND, *pastel over watercolor, 13½" × 21" (34.2 × 53.3 cm). Collection of the artist.*

The color in my watercolor Warm Winter Wind *had become slightly muddy. The values didn't seem to agree with my original concept of snow blowing off the top of this giant mountain, combining with the moisture in the air to create a cloud! I decided to use a medium we never think of as opaque—pastel—to complete this painting. In this painting, I let bits of the original watercolor show through. These chunks of color, plus the pebbly pastel texture, combine to create a "glue" that holds the painting together.*

133

PHOTOGRAPHS AS A RESOURCE

Throughout this book, I'm sure you noticed my heavy emphasis on the use of photography. It may seem contradictory then for me to say that I believe every landscape artist should have some outdoor painting experience before he begins to rely on the camera. I say this for two reasons: (1) It's just plain fun to work outdoors in a natural atmosphere. You've got the smell of the forest, the rustle of the leaves, and the occasional flash of a bird or deer zipping by. And (2), contrary to popular belief, the camera *does* lie. In each of these photos, you are seeing the same mountain and the same tree; the only thing that's been changed is the length of the lens.

If painting outdoors is so wonderful, how come so many watercolorists paint indoors? Well, the lightest summer breeze is able to steal more moisture from the air in thirty seconds than any dehumidifier could in an hour. Unless you live in southern Florida, that takes away "wet-time" that watercolorists desperately need.

So, if you are painting indoors, what do you do for subject matter? You could invent a scene, but it's time-consuming, usually inaccurate, and often boring. Also, if you don't have enough experience, you just plain *won't* be able to. You could work from sketches. This is an enjoyable way to accumulate

material, and most artists use it in conjunction with other methods. But, again, it's time-consuming, and it's difficult to do without a lot of experience.

Photography can work for anyone. All you need is a camera. If you don't already own one, I recommend a 35mm SLR (single lens reflex). With an SLR, you're viewing your subject through the same lens with which you'll be taking the picture, so it would be more difficult to cut off Aunt Edna's nose. One of the best SLRs around is the Pentax K1000. It's solidly built, has all the controls you need, and it's out-and-out cheap. For about twenty-five dollars more, you can purchase the Pentax K1000 SE, which is somewhat easier to use and has a better guarantee.

If you are able to buy this camera without the standard 50mm lens, you might consider purchasing a zoom instead. It will add about another one hundred dollars to the bill, but it will give you the equivalent of many lenses for the price of one. The zoom range that I consider ideal for landscapes will take you from a standard 28mm wide-angle to a moderate 105mm telephoto. Vivitar makes a beauty, and Kiron, whose lens can do everything the Vivitar can, has one at half the price.

Once you have your camera, learn how to use it. Imagine you're in a room with

one window (the lens). You open the window (the lens). The diaphragm (or F stop) of the lens determines how wide the "window" is open, and therefore how much light comes in. The difference in the amount of light reaching the film when you shift from one F stop to the very next F stop is exactly 200 percent (or 50 percent, depending on which direction). That means that when you shift your diaphragm from F11 to F8, you are letting in exactly *twice* the amount of light. When you go from F4 to F5.6, you're cutting the light in half.

There is another control that determines how long that window remains open. It's called the shutter, and it's calibrated in fractions of a second. When the shutter dial says 30, what it really means is 1/30th of a second, and when it says 250, it means 1/250th of a second.

A glance at the dial shows you that each number is either half or double the previous number; every time you shift to the next shutter speed, you're letting in either half or double the amount of light. If the proper exposure for a particular situation is F11 at 1/125th of a second, then F8 at 1/250th or F16 at 1/60th would give you an identical exposure.

What determines which combination I choose? Let's start with the obvious. The faster the shutter speed, the less chance that a moving object might be

210 mm Telephoto Lens

These photographs of Grand Teton National Park
were taken with lenses of different lengths.

110 mm Telephoto Lens

Standard 50 mm Lens

28 mm Wide-angle Lens

blurred. *How* fast is determined by three things: how long the lens is—a telephoto exaggerates movement; a wide-angle minimizes it. The direction of the action—a horse running across a field will be more blurred than one running toward you. And your steadiness.

Most camera manuals recommend that you use a shutter speed no slower than 1/125th with the standard 50mm lens. Personally, I think most people can hand-hold a camera down to 1/30th of a second or less if they know how. Always take a deep breath before you release the shutter; let half the air out, and then gently *squeeze* the button. If you can brace yourself against a tree or a rock, that should allow you to use even slower shutter speeds. But, remember, anything moving in the scene—a branch, blades of grass, an animal's tail—may end up "soft."

If you're using your 50mm lens or if your zoom is set to 50mm, that horse running *across* the field in the *distance* could probably be frozen at 1/125th of a second. If he's in the middle ground, choose 1/250th of a second, and if he's fairly close, select 1/500th or more. As a safety measure, any time you're not

certain what exposure to use, bracket. Take a photo at whatever the meter indicates, then take one at one speed faster and another at one speed slower. That's three times as much film, but you're ten times as certain of bringing home a prizewinner!

How do you know which F stop to select? The size of the F stop does more than determine how much light falls on the film; it also decides your depth of field (the area of sharp focus). When you set the diaphragm of your 50mm lens at F8 and you focus your camera at ten feet, everything from about eight feet to thirteen feet is in focus. As you shift to a smaller opening, that range becomes greater. However, you're cutting down the amount of light entering the lens, so you've got to use a slower shutter speed.

If you have a standard lens (*not* a zoom), you've got a depth of field scale printed on the side of your lens. Because knowing what's in focus is critical to a landscape painter, this is an important feature. Read your instruction manual carefully.

There's one more basic control on most cameras, a built-in light meter, which records how much light is falling on the

scene. If you adjust everything according to that information, you'll end up with a range of F stop/shutter speed combinations, any one of which will give you the proper exposure. However, with most SLRs, you've got to let the meter know which film you're using.

On each box of film or on a slip of paper in the box, you'll find something listed as ASA or ISO with a number after it. That number is the speed (or sensitivity) of the film, and that's the number you set on your camera's light meter. You don't have to change until you switch to a different kind of film.

What film should you use? Most films today are excellent, but I prefer Kodacolor 100 or 200 print film. I have it developed and printed as slides because it's cheaper that way. From the slides, I choose the best four or five from which I make 8 × 12 prints. I use 8 × 12s because they scale up perfectly from the 35mm format without being cropped. Since not all labs offer 8 × 12s, you might want to study the ads in some of the photography magazines.

In the end, I use a combination of prints, slides, and sketches from which to make my watercolors.

Opposite:
GOLD COUNTRY, CALIFORNIA
This 8" × 12" print is really a portion I cut out of a larger print. I especially like the way the trees frame the abandoned gold mine, but I wonder how much of the sky I will have to cut off.

GOLD COUNTRY, CALIFORNIA
The textures are wonderful on this old abandoned hotel. I know a small painting would never do them justice, but how big should it be? Perhaps it should be an oil (or acrylic) painting altogether?

WRIGLEY BUILDING,
CHICAGO, ILLINOIS
The backlighting on the smoke and the classic building intrigued me, but how much of the dark foreground building should I show? And how much detail do I put into the other buildings?

GRAND CANYON, ARIZONA
This, too, is a painting I tried once; it didn't work out. What if I painted a wash of waterproof cobalt acrylic paint over the foreground first? Would the watercolor adhere enough to the plastic surface of the acrylic to give the texture I'm looking for?

GALENA, ILLINOIS
Galena is a charming town, known for its restored nineteenth-century buildings. I tried painting this "gingerbread" house showing the electrical wires and the textures but was not successful in that attempt. I loved the textures in this building enough to try again. How intricately should I show the bric-a-brac? Shall I eliminate the wires?

CHOOSING
A FRAME

While it's true that a good frame can't save a bad painting, a great-looking frame can definitely help a *good* painting. I've been very fortunate in this regard. When I lived in Chicago, someone recommended Gudbrandsen Frame Company to me. Most of my early frames were made (and beautifully) by Chuck and his crew. Shortly after we moved to Jackson, about eight years ago, a studious-looking young man dropped into our gallery and announced that he and his wife had just opened a new frame shop in town. Mark and Susan Nowlin's Master's Studio has been doing all our framing since then, and we've become such good friends that frequently they know what I want before I do.

However, I know that many of you prefer to do your own framing. If you thumb through most art supply catalogs, you can find the equipment and materials to do so. My own favorite catalog house is Daniel Smith (4130 First Avenue South, Seattle, Washington 98134-2302). Their catalog is the prettiest I've seen, and it has the most and the best information about materials and art in general.

Once you get your catalog, look at the prices for framing equipment. A simple Dexter cutting knife is pretty inexpensive, but actually I haven't found it that much better than an X-Acto knife and a straightedge. The *real* mat-cutting devices can become fairly expensive. But this is one area where it doesn't pay to cut corners. If you frame a lot of paintings during the year and are willing to spend time learning to use a good mat-cutting machine, you can ultimately save lots of money by using it.

Keep in mind that unless you figure out some way to make use of the same color mat and frame on all your paintings (ho-hum!), you'll end up buying and having to store all kinds of mat boards and frame moldings. Personally, I'd rather spend the time making a second painting, and paying Mark and Susan to frame my work.

As far as mats are concerned, I find that a lot of people out there feel secure only with the safe, lighter, neutral colors when it comes to mats and frames. Therefore, what often works well to introduce a bit of variety and interest and still please the customer is to make the main mat a fairly light, neutral color and then use a bolder color note, suggested by the painting itself, in the narrower secondary mat. The following photos will show you different ways of doing this or of giving the impression of doing this—without the additional cost!

For these simple, inexpensive drawings, I didn't want to use custom frames. I ordered mass-produced frames from Graphik Dimensions Ltd., Dept. A, 41-23 Haight Street, Flushing, New York 11355. When they arrived from New York, Mark cut a single warm-gray mat and a glass, and I put it all together myself. (The frame came with the linen liner shown.)

The double mat works well here. The warm gray outside mat repeats the warm grays in the painting, and the slim brown inner mat duplicates the hot brown accents. The frame is a different story. Made of separate pieces of rough "barn wood" joined together to form a lip, it's the real thing—I've got the slivers to prove it—and it's beautiful! Also, it weighs a ton!

This watercolor, painted in sepia only and matted with a single light-brown mat, is part of an ongoing series. To create the feel of a second mat, a dark brown line is drawn about the mat. A distressed wood frame holds everything together. Mark buys the materials in quantity and cuts everything the same size at once. A great savings for me.

The outside of this double mat is a rich tan color that picks up the warm soft tans in the painting. The narrow inside mat is a dark green that matches the greens in the painting and in the frame, which is a beautiful natural wood that has been finished with a thick, glossy, transparent lacquer. A perfect combination!

The single mat has been covered by the framer with an olive-colored burlap. Notice that there are no seams. Because burlap has an open weave that could overwhelm a small painting or one with delicate detail, it should be used only on bigger, broader paintings. The frame here, which is made of white Formica with a rough wood-grained finish, contrasts nicely with the smooth white interior edge.

In order to set off a medium-tone painting with fairly bland colors in it, Mark and I dreamed up this light-dark-light arrangement, which cost no more than a double mat and worked perfectly as well. So that the painting wouldn't be lost, we used the mat of a less subdued color as the inside mat and the lighter one on the outside. This combination worked perfectly.

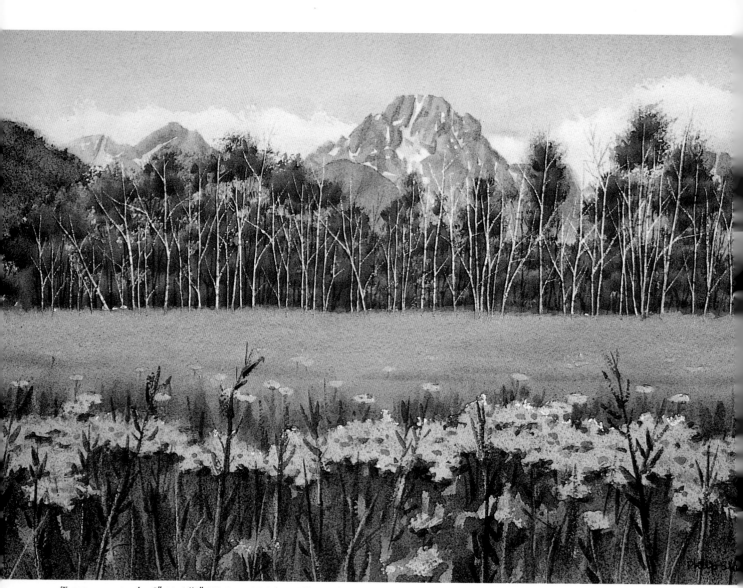

TAPESTRY, watercolor, 9" × 14½" (22.8 × 55.8 cm). Collection of Mr. and Mrs. Ron Alberts.

INDEX